POSTCARD HISTORY SERIES

Newark
The Golden Age

D0898677

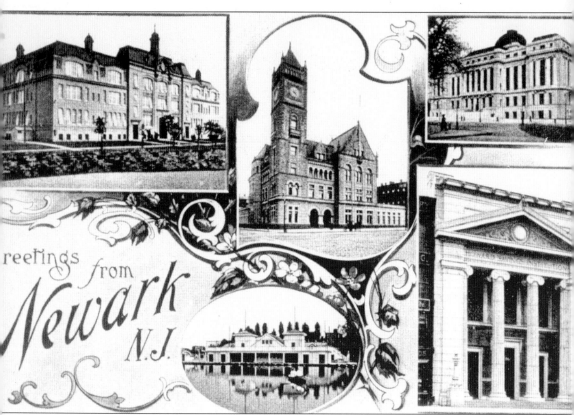

The postcard with the words "Greetings from Newark, N.J." contains five photographs of important buildings *c.* 1910. They are, from the top left, the Newark, or Barringer, High School, the first high school in the city; the U.S. Post Office; city hall; the Howard Savings Bank; and the boathouse at Branch Brook Park.

POSTCARD HISTORY SERIES

Newark
The Golden Age

Jean-Rae Turner, Richard T. Koles,
and Charles F. Cummings

ARCADIA

Copyright © 2003 by Jean-Rae Turner, Richard T. Koles, and Charles F. Cummings.
ISBN 0-7385-1214-1

First printed in 2003.

Published by Arcadia Publishing,
an imprint of Tempus Publishing Inc.
2A Cumberland Street
Charleston, SC 29401

Printed in Great Britain.

Library of Congress Catalog Card Number: 2003104307

For all general information, contact Arcadia Publishing:
Telephone 843-853-2070
Fax 843-853-0044
E-mail sales@arcadiapublishing.com

For customer service and orders:
Toll-free 1-888-313-2665

Visit us on the Internet at www.arcadiapublishing.com.

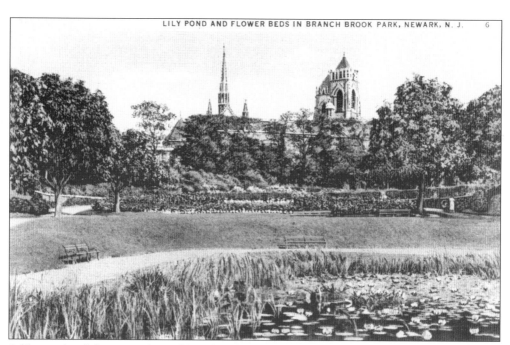

LILY POND AND FLOWER BEDS IN BRANCH BROOK PARK, NEWARK, N. J. 6

A lily pond and flower gardens add to the beauty of the Basilica Cathedral of the Sacred Heart,
adjacent to Branch Brook Park (background). This view dates from *c.* 1930.

CONTENTS

ACKNOWLEDGMENTS

We are grateful to the people who assisted us in assembling this book, including Valerie Austin, Robert Blackwell, April Kane, James Osborne, and Willis Taylor of the New Jersey information section of the Newark Public Library, Chris Craig, Robert Fridlington, William Frolich, Michael Giangeruso, Wilma Koles, Richard Musko, Steve Pawlowski, Lester Sargent, Charles Shallcross Jr., Herbert Singe, E. Jane Townsend, Howard Wiseman, William H. Wright, Lauren Yeats, and Michael Yesenko.

INTRODUCTION

The 20th century offered many opportunities to Newarkers. One of these was quick and easy communications with friends and neighbors by the new postcards invented in 1901. These cards were inexpensive—only 5¢ each, with a stamp that cost an additional penny. They could be mailed in the morning and delivered to the recipient by the mailman in the afternoon. Although many of the postcards were discarded, hobbyists became collectors of the attractive cards. Some limited their collections to only one theme, such as automobiles, airplanes, horses, schools, special cities, or parks. The scenes usually were taken by local photographers for German printing firms, which produced the cards. Until 1906, the messages were placed on the front of the cards—sometimes on the photographic images—and the addresses were written on the back. Cards printed after 1906 contain a single line in the middle of the back of the card to separate the message from the address, leaving the illustration on the front unharmed. The bulk of the postcards used in this book are from the New Jersey section of the Newark Public Library, at 5 Washington Street. In October 2002, the library received the first award for being the most outstanding library in the state. The postcards are only one example of the abundant amount of material on New Jersey available in that section. Without these postcards, there would be no *Newark: The Golden Age*. Newark's golden age extended from 1900, after the Spanish-American War, until *c.* 1930, when projects only begun or planned in the 1920s were completed. During those years, the city celebrated its 250th anniversary and had a widely diverse and profitable industrial and commercial base, good transportation, a growing population of about 237,000 people in 1900 to 347,569 by 1910, expansion of public education, the first county parks in the nation, beautiful monuments, attractive subdivisions, and friendly churches.

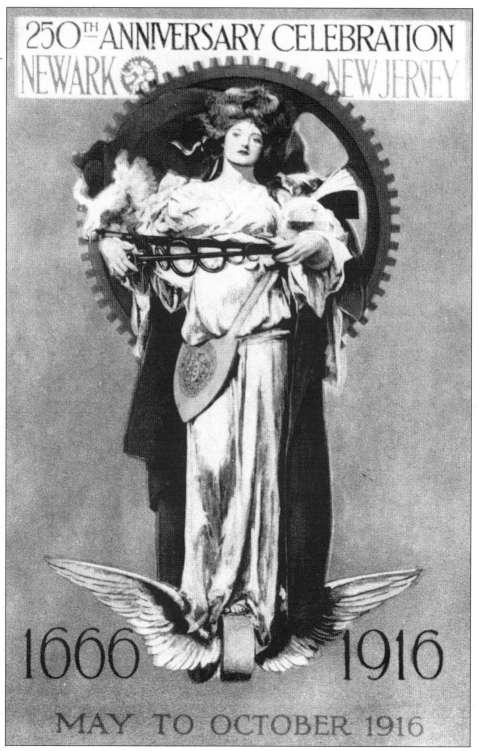

This Greek goddess figure invites people to the 250th anniversary celebration of the settlement of Newark by displaying instruments used in industry.

One
A CRADLE OF COMMERCE AND INDUSTRY

The city of Newark has had many grand celebrations in its 337-year history, including the Industrial Fair in 1872. The greatest of these was probably the six-month-long 250th observance of the anniversary of settlement of Newark, from April to October 1916. It became a model for festivities in cities throughout the nation. One of the events participated in by artists throughout the world was the making of posters announcing the anniversary. The next six pages contain award-winning posters used to advertise the observance. Most of the posters feature Greek and Roman gods and goddesses. However, one depicts an original Puritan, one of the first settlers in 1666; another shows the city as it appeared in 1916, at the height of the golden age; a third portrays a Native American. The celebration planned by a committee of 100 persons featured parades, concerts, dramatic productions, sporting events, operas, the dedications in Weequahic Park of the monument on the historic border between Newark and Elizabethtown and of the statue of Gov. Franklin Murphy, dances, and an ode by South Park Presbyterian Church pastor Rev. Dr. Lyman Whitney Allen.

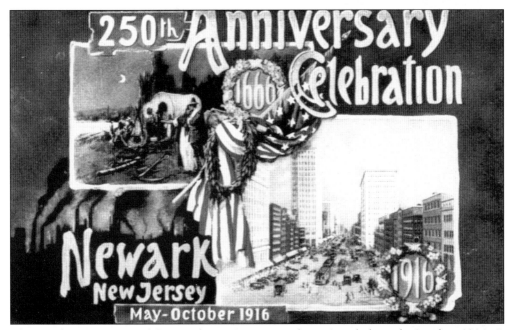

The 250th-anniversary celebration began in May and continued through October 1916. It featured promotional posters and postcards, including the one shown, parades, dedications of statues and plaques at historic sites, commemorative programs on the city's past, concerts, and a book on Newark's history. This is a 1916 view of Broad Street and the early settlers in 1666.

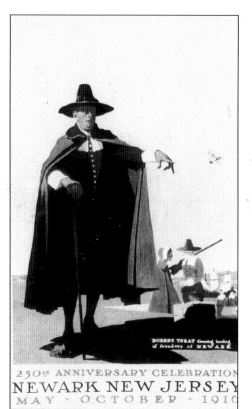

250ᵗᵸ ANNIVERSARY CELEBRATION
NEWARK NEW JERSEY
MAY · OCTOBER · 1916

Robert Treat, the Puritan lay leader of the settlers of Newark, directs the landing of Connecticut settlers at Newark in May 1666. Treat acted as the military leader. Rev. Abraham Pierson Sr., who arrived in 1667, served as the theological leader. Newark was a theocracy: only men who belonged to the Congregational Church were allowed to vote or hold office.

NEWARK
NEW JERSEY

250ᵗʰ Anniversary
Celebration
1666–1916

MAY to OCTOBER 1916

A ship, women in fancy gowns, and children at play are featured on this poster advertising the 250th anniversary of the founding of the city of Newark in 1666.

This poster of Roman legionnaires and a horse announces Newark's anniversary celebration. The seal of the city of Newark is in the background. The man at the right may be a blacksmith carrying a hammer and chains.

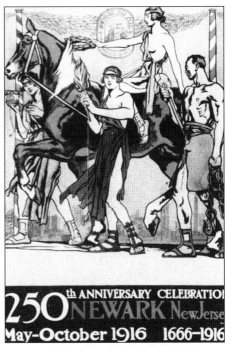

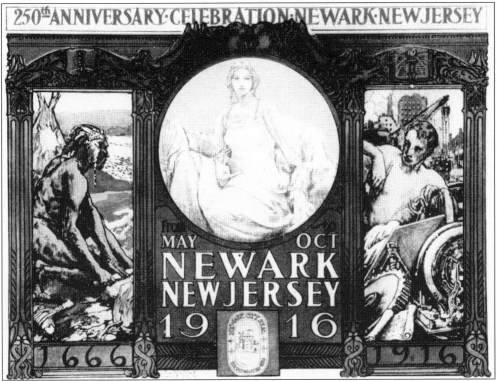

A Lenape Indian on the Passaic River with a tepee behind him looks toward the future development of the industrial city on the right. Historians estimate that there were only 5,000 Native Americans in the colony when Newark was established.

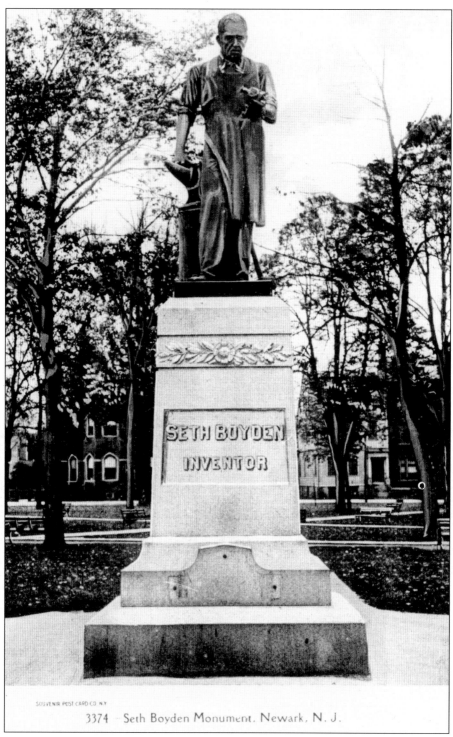

SOUVENIR POST CARD CO. N.Y.

3374 — Seth Boyden Monument. Newark, N. J.

Karl Gerhardt's statue of inventor Seth Boyden stands in the center of Washington Park. Boyden is credited with making Newark an industrial city. The statue was unveiled in 1890. The only statue in the city of a laboring man, it shows Boyden wearing a leather apron.

Two

THE INSURANCE AND BANKING CENTER

Seth Boyden arrived in Newark in 1815 and set up shop on Orange Street near the Bridge Street bridge, the first pedestrian and wagon bridge across the Passaic River in Newark. He had already developed a machine to slice leather. He developed malleable iron and patent leather, built two locomotives, and discovered a new method for silver-plating buckles, harness ornaments, and other items. He constantly sought to improve or invent new methods for performing tasks. He established companies to make his inventions but sold the companies and went on to solve another problem. After he moved to Hilton, a section of the future Maplewood on the Union Township line, he developed large strawberries. He attempted to do a contemporary a favor by inventing a hair dye so he would appear younger than he was. He put the dye on the man's head and it worked well—until it turned purple. Like Boyden, Newark became known for its diverse industries, which produced celluloid, varnish, paint, jewelry, machinery, various foods, carriages, accessories for carriages, fountain pens, cigars, ice cream, garments, electrical products, beer, textiles, thread, silverware, and many other products. The various industries created a necessity for banks and insurance companies, and the city became noted for them. The industries, banks, and insurance companies attracted employees, who shopped for food, clothes, furniture, and other products, causing many stores to open. Newark quickly grew to be the largest city in New Jersey.

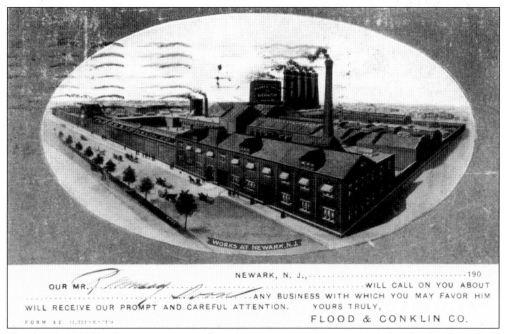

Flood and Conklin Company, a varnish maker, was one of the many industries in Newark. It apparently had other factories because the card adds "Works At Newark."

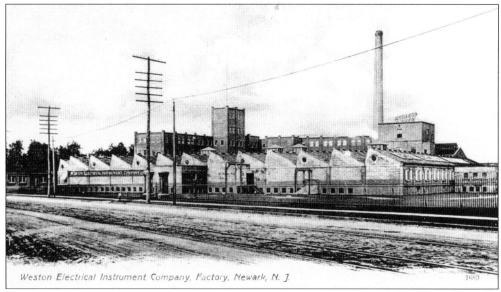

Weston Electrical Instrument Company, Factory, Newark, N. J.

The Weston Electrical Instrument Company was opened by inventor Edward Weston, who is compared favorably to Thomas Alva Edison. Weston installed the first arc lights at Military Park and went on to invent many electrical products. He received some 300 patents for his inventions.

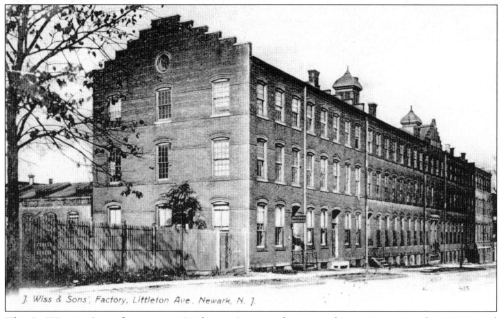

J. Wiss & Sons', Factory, Littleton Ave. Newark, N. J.

The J. Wiss & Sons factory, on Littleton Avenue, began making scissors in the 1840s and gradually increased its production to jewelry and silverware. During World War II, it made items for the war effort. The company opened a jewelry store on Broad Street. In 1978, the store was moved to the Short Hills Mall.

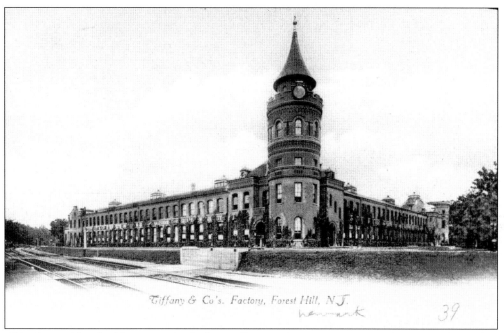

Tiffany & Co's. Factory, Forest Hill, N.J.

This fortresslike building was built by Tiffany and Company, manufacturers of jewelry, silverware, tombstones, and stationery. The building was converted into condominiums after it was sold in 1984.

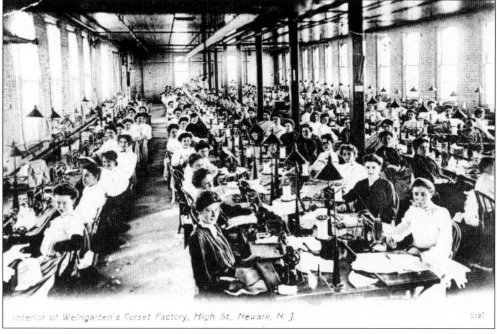

Interior of Weingarten's Corset Factory, High St., Newark, N. J.

Women at Weingarten's Corset Factory, on High Street, stopped working at their sewing machines long enough to pose for this company postcard. Most of the women in textile factories did piecework, so it is unusual to see them idle.

15

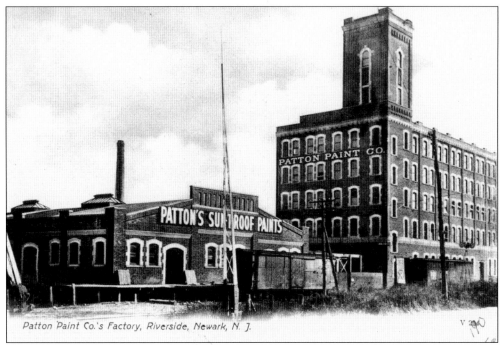

Patton Paint Co.'s Factory, Riverside, Newark, N. J.

Newark became known for its paint and varnish manufacturing. This is a view of the Patton Paint Company's factory, on Chester Street at the riverside. Note the words "Patton's Sunproof Paints" on the one-story building.

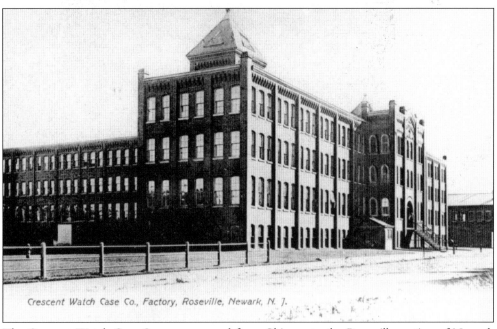

Crescent Watch Case Co., Factory, Roseville, Newark, N. J.

The Crescent Watch Case Company moved from Chicago to the Roseville section of Newark in 1891 and built this huge factory. Nearly all watchcases in the nation were manufactured in Newark during this period.

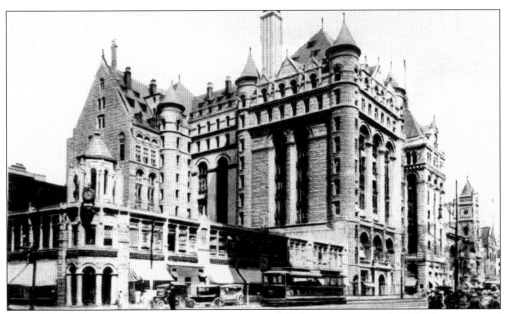

The Prudential Insurance Company moved into this Romanesque and Gothic building on Broad and Bank Streets in 1892. The building resembles a Loire Valley French chateau. Although the company was started in 1873, this was its first official home.

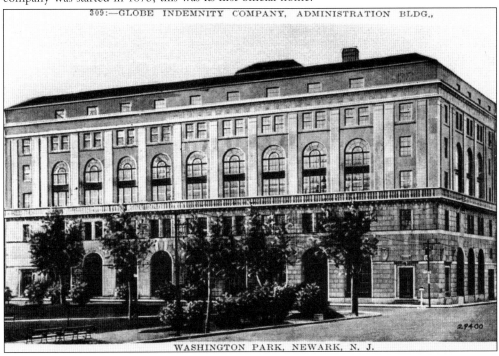

309:—GLOBE INDEMNITY COMPANY, ADMINISTRATION BLDG.,

WASHINGTON PARK, NEWARK, N. J.

The Second Renaissance Revival–style Globe Indemnity Insurance Company building was erected in 1920 at 20 Washington Place. It was designed by Frank Goodwillie. In 1946, the company was acquired by the federal government to serve the Veterans Administration. Restored in 2001–2003, the building is part of the James Street Commons Historic District and is listed on the National Register of Historic Places.

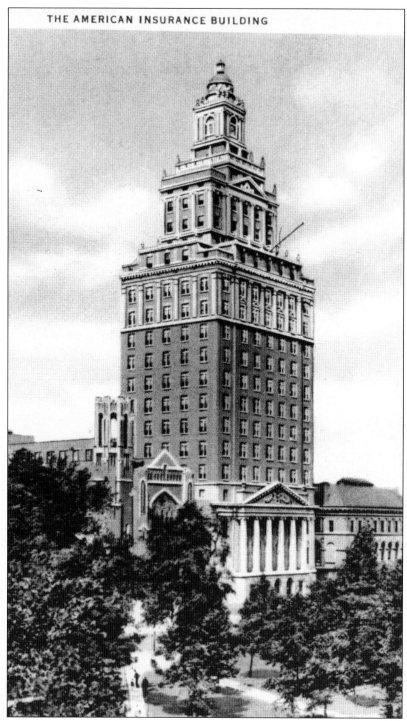

The American Insurance Company, on Washington Park, is one of the most attractive skyscrapers in the city. It was built in 1930. Most recently, it housed the Rutgers University Law School. Future use may include a new hotel. The Newark Public Library is the low building on the right.

The building on the right was known as the Metropolitan Building and the U.S. Credit System Building, on Washington Street at Branford Place. The Empire Theater, featuring burlesque, is on the left. The theater closed c. 1958.

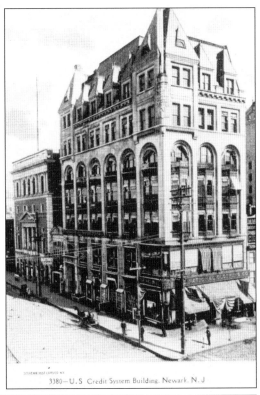

3380—U.S Credit System Building. Newark. N. J

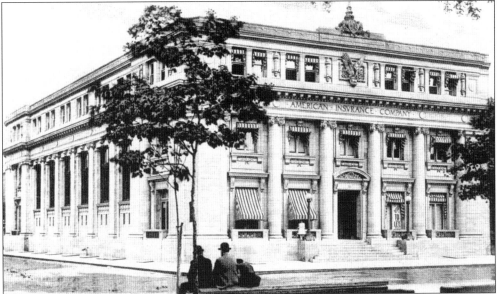

The American Insurance Company started with four employees in 1846, when Newark had only 5,000 people. By 1946, when it observed its 100th anniversary, the company had 1,100 employees. The city's population was 429,760 in 1940 and 438,776 in 1950. The company built this Classical building, designed by Cass Gilbert in 1904, on East Park Street and Park Place. When the Public Service Gas and Electric Company next door was erecting a new building in 1981, this building was razed.

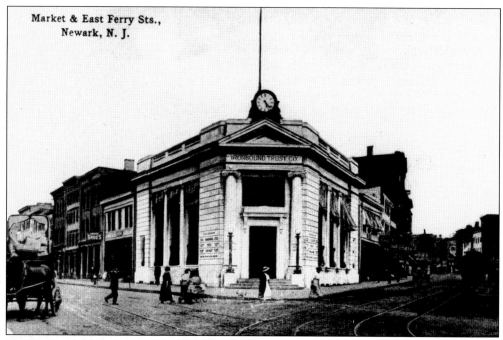

Market & East Ferry Sts.,
Newark, N. J.

The Ironbound Trust Company stood at the intersection of Market and East Ferry Streets in 1910. The site was occupied by banks for many years.

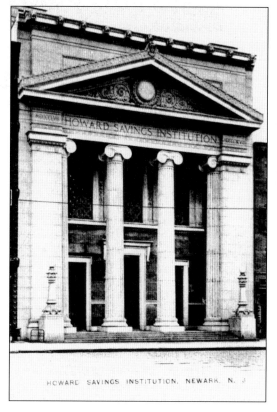

The Howard Savings Bank, on Broad Street, opened in 1857 and encouraged small accounts by factory and office workers. In the early 1920s, it encouraged weekly deposits by children in the Newark schools.

20

The Federal Trust Company was formed in 1901 by some of the leading citizens of Newark, including department store proprietor Louis Plaut, brewery owners Arthur C. Hensler and Gottfried Krueger, and future congressman Hamilton Fish Kean. The bank offices were on Broad Street between Bank and Academy Streets.

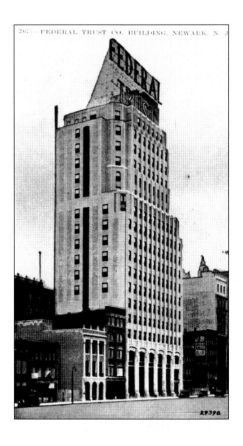

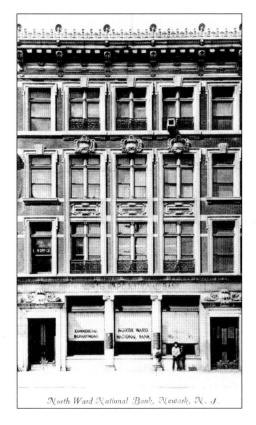

North Ward National Bank, Newark, N. J.

The North Ward National Bank was one of several banks to take the name of the neighborhood in which they were located.

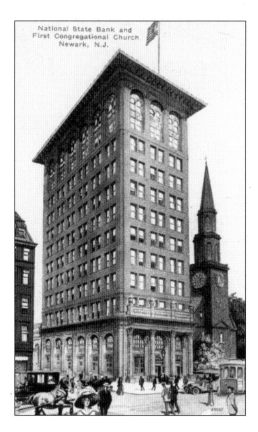

The National State Bank began in 1812 as a state bank. It later became a national bank. It was the first and oldest bank in the city. This 12-story building towers over the steeple of the old First Presbyterian Church, the first religious congregation in Newark. It was a Congregational church until *c.* 1717, when it became Presbyterian.

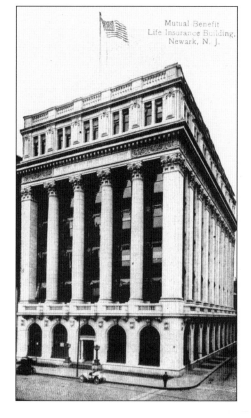

The Mutual Benefit Assurance Society (later, the Mutual Benefit Life Insurance Company) was founded in 1846. The company built this seven-story white granite and marble building at Broad and Clinton Streets in 1905. It moved in 1926 to a classical building on Broadway. By 1957, the company was back on Broad Street in a 20-story building, with a parking garage. The Broadway site became Essex County Boys Catholic High School. It is now a nursing home. Since 1999, the 520 Broad Street site has been occupied by IDT Corporation.

The Military Park Building was constructed in 1925 on Park Place opposite Military Park. The roof is designed to look like a medieval fortress. There are military symbols and figures between the windows, in keeping with the building's name. The Robert Treat Hotel is at the left of the building. It is named for the military leader of the first settlers from Connecticut.

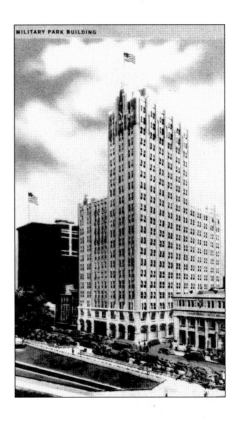

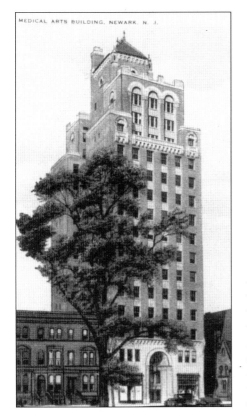

The Medical Arts Building, at Lincoln Park, was built in 1927. When it opened, the 19-story building was the tallest in the park area. Architect William E. Lehman selected a Mediterranean design for the structure. It provided office space for many of Newark's prominent physicians and dentists, who lived nearby. It was abandoned in the late 1960s or early 1970s and converted into senior citizen housing in 1982.

23

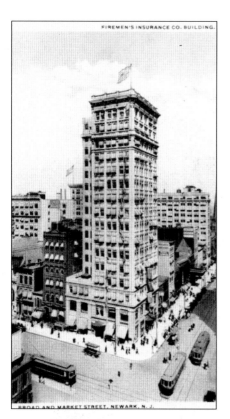

The Firemen's Insurance Company stands on an earlier site, at the northeast corner of Broad and Market Streets. It was 16 stories tall, higher than any other buildings along the street when it was built in 1916.

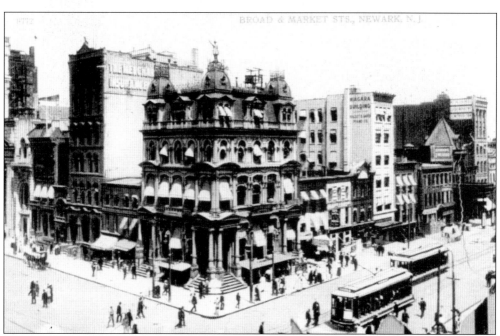

From 1868 to 1916, the earlier Firemen's Insurance Company occupied this building, also at Broad and Market Streets. It featured the company's trademark, a statue of a fireman, on the roof.

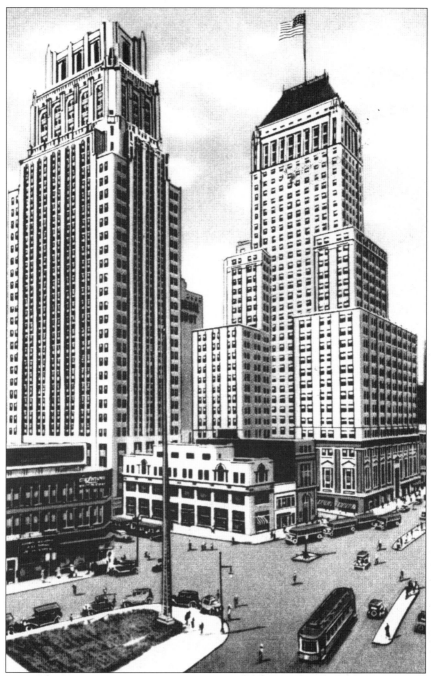

The Lefcourt Building (now the Raymond–Commerce Building) was named for its builder, who suffered severe losses in the Crash of 1929. It stands at the left on the site of the old city market between the two streets. Newark architect Frank Grad designed the Art Deco building. Its planned future use is as a residence. The National Newark and Essex Building, on the right, is the tallest structure in Newark. It is being renovated to its original splendor and already houses numerous offices. The National Newark and Essex Building now is known as the 744 Broad Street building.

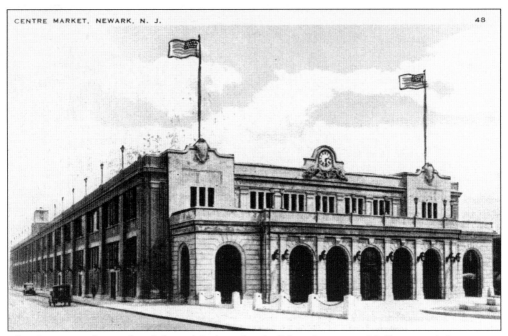

The Center Market replaced the original market building. It was on Mulberry and Commerce Streets and the Morris Canal. The canal became Raymond Boulevard, and the market became a state office building in the early 1950s.

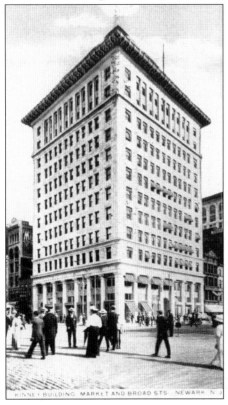

The Kinney Building stood on the southeast corner of Broad and Market Streets. Built in 1912, it was one of Newark's first skyscrapers.

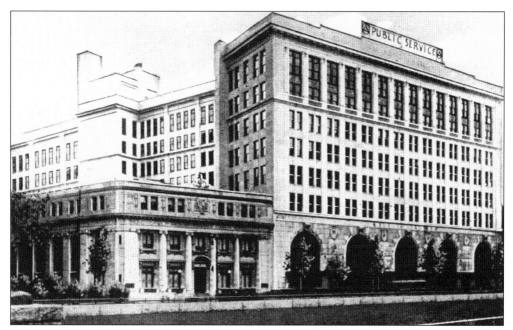

The Public Service Electric and Gas Company building, on Park Place, was erected in 1916. The company later expanded into the former American Insurance Company office at the left. The complex was razed to make room for the 26-story glass-walled building in 1981. A plaza in front of the new building is used for concerts and festivals.

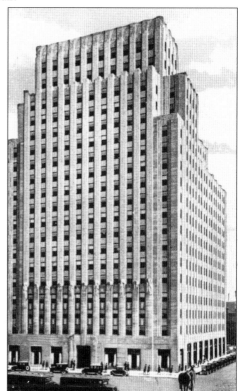

The New Jersey Bell Telephone building, opposite Washington Park, is now part of Verizon. It was designed by Voorhees, Gmelin and Walker of New York City in the American Perpendicular style. Its lobby is noted for its Art Deco design. A cornice along the third floor shows people talking on telephones.

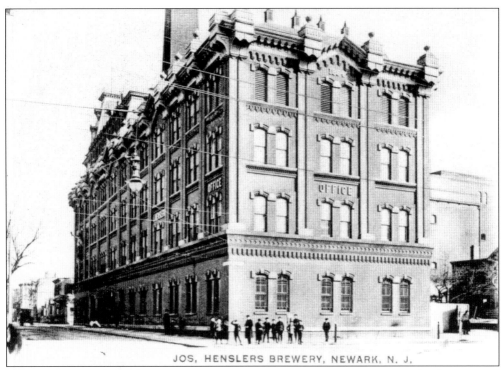

JOS, HENSLERS BREWERY, NEWARK, N. J.

Joseph Hensler opened his brewery in 1860, after working at Lorenz and Hensler for 10 years. He lived next to his brewery. He later bought Lorenz's share and incorporated it in 1889 with his sons, Joseph Jr. and Adolph. The brewery closed in 1958.

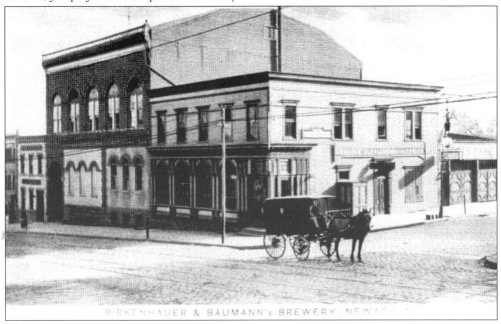

BIRKENHAUER & BAUMANN's BREWERY, NEWARK

The Birkenhauer and Bauman Brewing Company was one of the many small breweries in Newark in the 19th century. Most of the breweries were operated by Germans who immigrated to Newark after 1848.

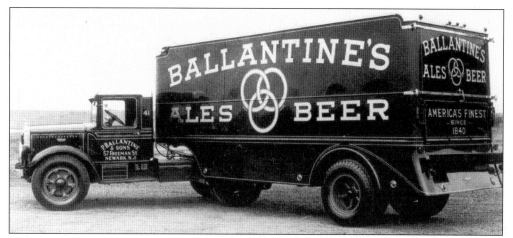

More than 500 trucks like this one carried kegs of beer to outlets from the Peter Ballantine and Sons Brewery in the 1940s and 1950s. Some 600 freight cars carried beer and ale across the nation. The brewery, Newark's largest, was started in 1840 by a Scotsman.

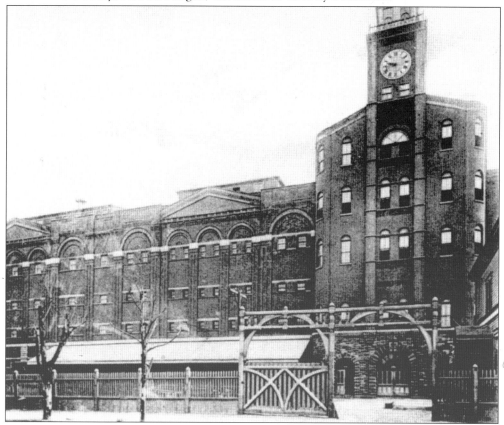

The Christian Feigenspan Brewery opened in 1869 on Freeman, Brill, and Fleming Avenues at the Morris Canal (later Raymond Boulevard). Its slogan was P.O.N. for the "Pride of Newark." The letters on the building were lighted throughout the Depression and turned off only when the factory closed in 1944, after being purchased by P. Ballantine and Sons. The Feigenspan mansion still stands on High Street (now Rev. Dr. Martin Luther King Boulevard).

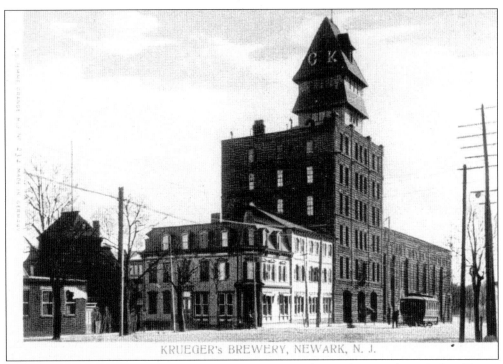

KRUEGER's BREWERY, NEWARK, N. J.

The Gottfried Krueger Brewing Company was at 75 Belmont Avenue (now Irvine Turner Boulevard) and West Kinney Street. Opened in 1865, it soon covered two blocks. In 1889, it became part of the United States Brewing Company, controlled by the Krueger family. During Prohibition, it made soft drinks. The company introduced the sale of beer in cans in 1940. It closed in 1960. The company's statue of Gambrinus, the mythical inventor of beer, stood over the front door of the brewery for many years.

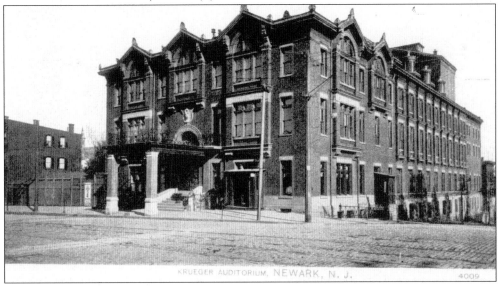

KRUEGER AUDITORIUM, NEWARK, N. J. 4009

The Krueger Auditorium, initially Saenger Hall, was built by Gottfried Krueger in 1885 for concerts, dances, and dinners. Each beer baron in Newark attempted to do something to attract customers, in addition to selling beer.

30

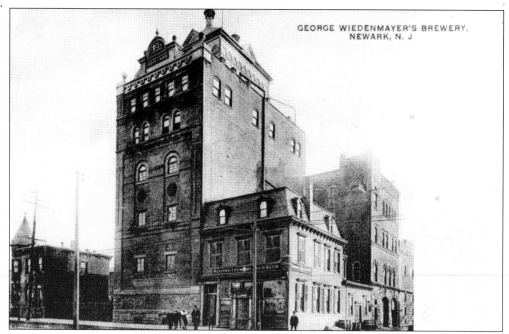

Wiedenmayer's Newark City Brewery began in the 1850s in the Ironbound section. Soon, the brewery grew to three buildings, a stable for 36 horses, and a cold storage center for 20,000 barrels of beer. Wiedenmayer's built a baseball stadium for Newark. The company closed in 1958.

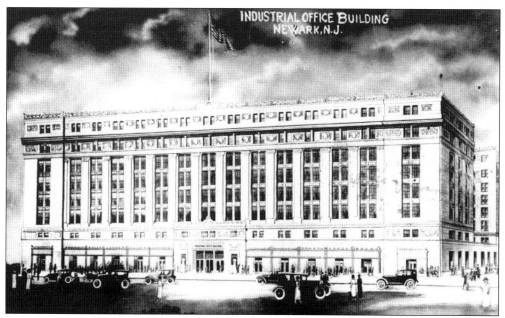

The Industrial Office Building, at 1060 Broad Street, opened in 1927 as an office and exhibition center. For many years it provided office space for Newark's lawyers. The eight-story building contained 400,000 square feet of space and a restaurant. It was designed by Frank Grad and Henry Baechlin. It closed in the 1970s. Later, it was converted into 450 units for senior citizens. Today, it is known as Essex Plaza.

Watson and Company—a store, lawyers' offices, and a telephone company— occupied these buildings on Market Street.

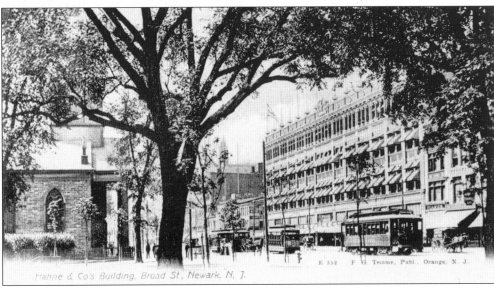

Hahne & Company was the oldest department store in Newark. It was begun in 1858 by Julius Hahne. It began handling general merchandise in the 1870s. The present building was opened on Labor Day 1901. The store became a favorite of women who would come into the city in their carriages to shop and have lunch at Hahne's. It was the last large department store in the city to close. It is scheduled to be included in the redevelopment of the area into residences, stores, and offices.

32

Three
THE SHOPPING CAPITAL
OF NEW JERSEY

Newark became the shopping center for New Jersey as several large departments stores attracted people from throughout the state. The numerous hotels provided clean, safe, and comfortable facilities for an overnight visit, and convenient service by five railroads and seven railroad stations provided easy and quick access to the city. For those who did not wish to walk between stores, there were trolley cars, jitney buses, and Hanson cabs. The three major stores, Hahne & Company, L.S. Plaut, and L. Bamberger, were just blocks apart. The hotels ranged from the Robert Treat, a luxury hotel, to family hostels like the St. Francis and the Riviera. In addition to shoppers, the railroads brought a new class of people: those who commuted to their jobs in Newark from the farmland outside the city. The railroads also provided easy access to vacation hotels and new residential subdivisions in the suburbs, and they opened up the Jersey Shore and the highland lakes, both of which became popular summer resorts where many Newarkers owned vacation sites.

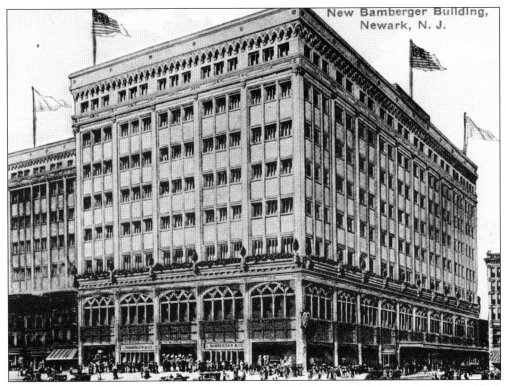

New Bamberger Building, Newark, N. J.

L. Bamberger and Company stands on the corner of Market and Washington Streets *c.* 1916. Horses and wagons are still being used, but automobiles and trucks are making their appearance. The store sponsored a Thanksgiving Day parade for many years.

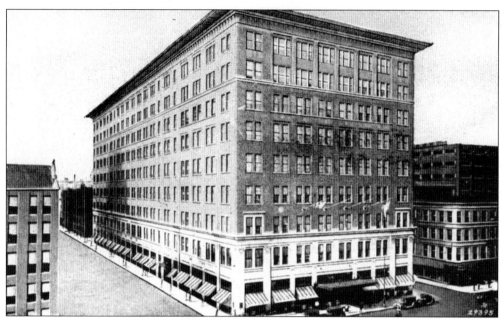

The Kresge Department Store, on Broad Street at Raymond Boulevard, was started in 1876 by Simon Plaut and Leopold Fox as L.S. Plaut Department Store. It became known as the Bee Hive Store. Sebastian Kresge purchased the store and built this building in 1923. The Chase Department Store purchased the store in the 1960s. Later, it became Two Guys from Harrison. The board of education now uses it for offices. Several small stores are located on the first floor, fronting on Broad Street.

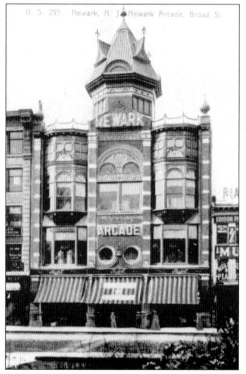

The Arcade extended from Broad to Halsey Streets along New Street. It contained a mixture of stores and offices. For three years *c.* 1908, a theater also was operated in the Arcade.

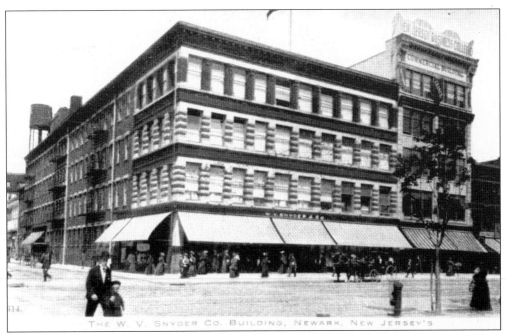

The W.V. Snyder Company was known as the city's oldest dry goods store. A spokesman for the store recalled that it was normal for people to call the store and ask, "Has Aunt Sarah been in yet this morning?" because some women made regular daily visits, and the store personnel knew them all.

The Christian Schmidt Furniture Company sold both furniture and carpets at this store at 157 Springfield Avenue. It claimed to be the largest and most complete furniture store in the city. The flags on top of the building, like all of the flags on top of all of the buildings shown in these postcards, were added after the photograph was taken.

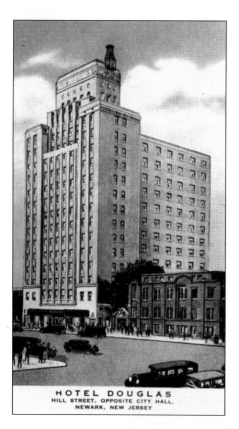

HOTEL DOUGLAS
HILL STREET, OPPOSITE CITY HALL,
NEWARK, NEW JERSEY

The Hotel Douglas was surrounded by brownstone houses when it was erected on Hill Street near city hall *c.* 1930. New Community Corporation purchased the hotel for a senior citizens residence.

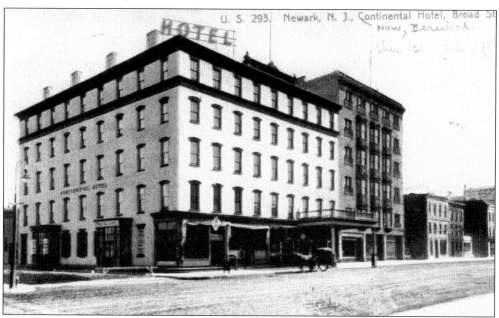

The Continental Hotel, on Broad Street, served the public early in the 20th century. It became the Berwick Hotel, a popular gathering place for the youth of the city in the 1940s. Its final name was the Benzell Hotel.

36

The St. Francis Hotel was taken over by the U.S. government during World War II to house army personnel stationed at the Newark Airport. After the war, it resumed being a residential hotel.

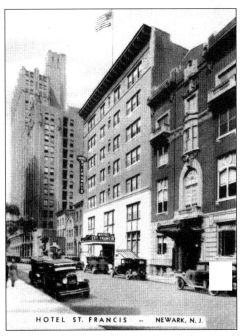

HOTEL ST. FRANCIS — NEWARK, N. J.

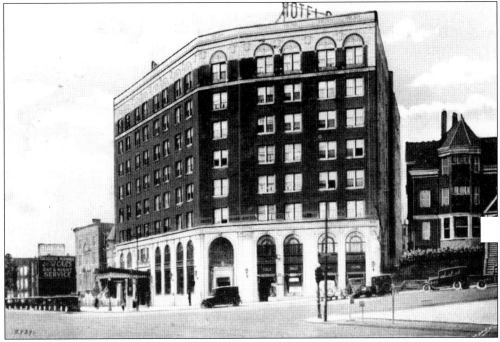

In October 1949, the Rivera Hotel, on the corner of High Street (Rev. Dr. Martin Luther King Boulevard) and Clinton Avenue, was purchased by George Baker, known as Father Divine. The purchase was made by two men who arrived in Newark with $500,000 cash in small bills. Father Divine closed the hotel's bar and removed all cigarette machines. He sanctioned a life of chastity, abstinence, shared income, communal living, hard work, economic security, honesty, and payment of purchases with cash. It is estimated that at one time he had more than 10,000 followers in Newark. The postcard dates from *c.* 1930.

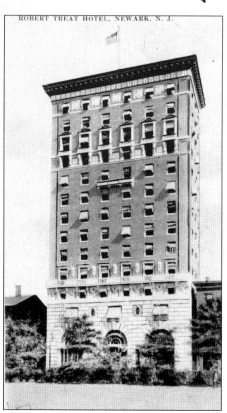

ROBERT TREAT HOTEL, NEWARK, N. J.

The Robert Treat Hotel, on Park Place, is named for the civilian leader of the settlers of Newark in 1666. It continues to be one of Newark's luxury hotels.

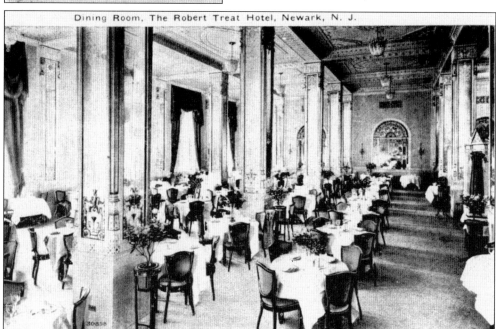

Dining Room, The Robert Treat Hotel, Newark, N. J.

From its start, the Robert Treat Hotel, on Military Park, was noted for its fine dining. Many of the city's celebrations are conducted in the hotel's ballroom. This view was taken in the early 20th century.

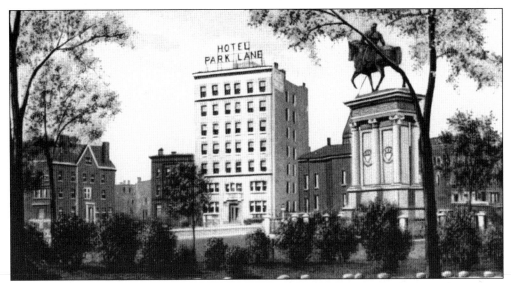

The Hotel Park Lane was opposite Lincoln Park during Newark's golden age. At the right in Clinton Park is the Colleoni statue, donated to the city by Christian Feigenspan, a banker and son of the brewer.

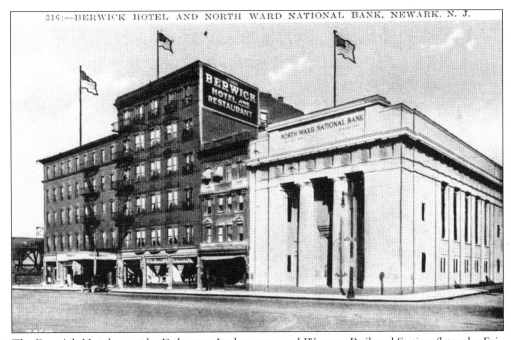

The Berwick Hotel, near the Delaware, Lackawanna and Western Railroad Station (later the Erie Lackawanna) and the North Ward National Bank, served the area during Newark's golden age. Part of it was the Continental Hotel. Its last name was the Benzell Hotel.

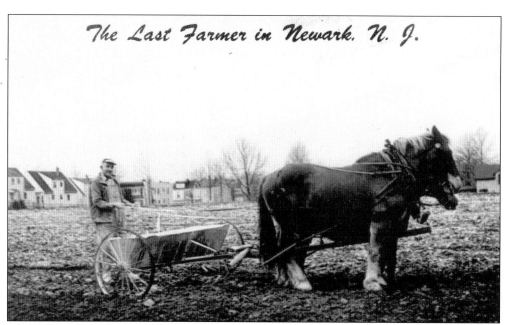

The Last Farmer in Newark. N. J.

Lum Rallensky drives two horses on the last farm in Newark in the early 1950s. Horses were still being used in the city's streets to pull peddlers' wagons. Some peddlers sold vegetables and fruit, and others repaired shoes.

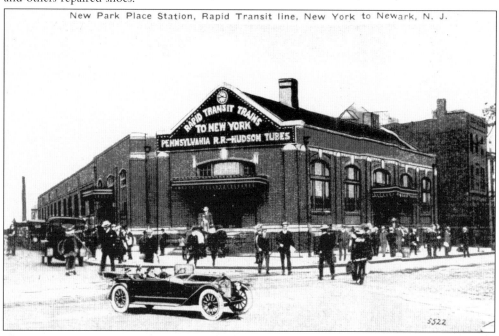

The Hudson and Manhattan Railroad Station served the rapid-transit trains to New York City. Commonly called the Hudson tubes, the trains provided easy access to midtown Manhattan through a tunnel, which was completed in 1910. The tubes began operating in 1911 from the station near Park Place. In March 1935, the tubes were moved to the third level of the new Pennsylvania Railroad Station. The New Jersey Performing Arts Center opened across the street from the old station site in 1997.

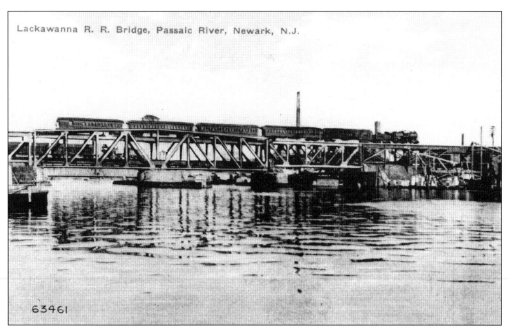

Lackawanna R. R. Bridge, Passaic River, Newark, N.J.

63461

The Lackawanna Railroad Bridge was built in three sections. Today, it is close to the bridge for Route 280. The crossing is also near the Erie Lackawanna Railroad Station on Broad Street.

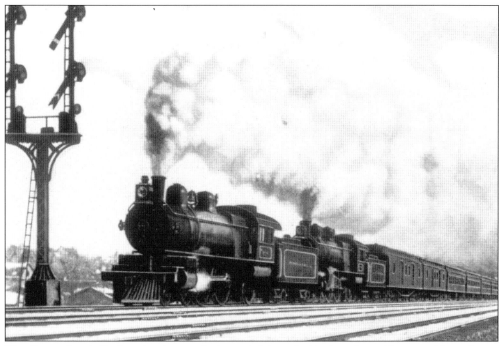

The Pennsylvania Railroad train travels through Newark. During the golden age, Newark was served by five railroad lines: the Pennsylvania, the Lehigh Valley, the Central Railroad of New Jersey, the Erie Railroad, and the Delaware, Lackawanna and Western. The Baltimore and Ohio Railroad used the Central Railroad tracks.

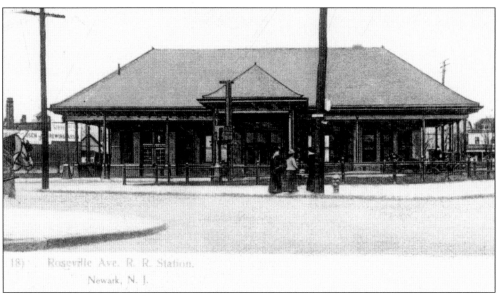

The Roseville Avenue Railroad Station was across the street from the tracks of the Delaware, Lackawanna and Western Railroad.

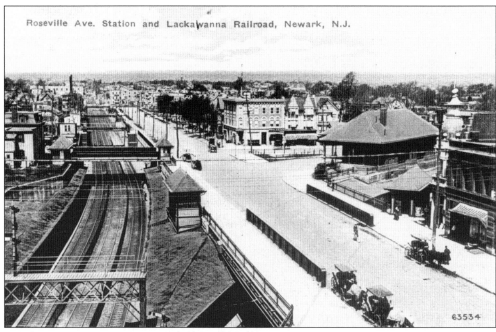

The Roseville Avenue Railroad Station of the Lackawanna Railroad is at the right. The railroad tracks here are depressed to eliminate dangerous grade crossings. Bridges cross the tracks at each side street. The official name for the railroad was the Delaware, Lackawanna and Western Railroad. Later, it became the Erie Lackawanna Railroad. The New Jersey Transit now operates all passenger railroad lines in New Jersey.

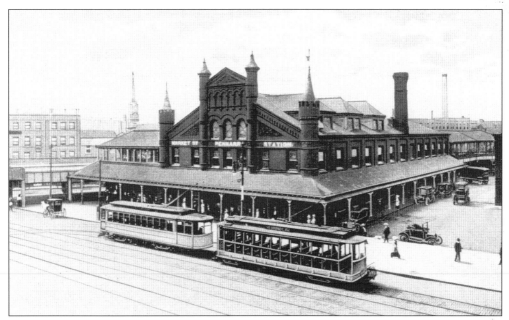

The Pennsylvania Railroad Station, with its towers and turrets, was located southwest of the present Penn Station on the opposite side of Market Street. This building featured a roof that sheltered passengers from rain, snow, and sun while they waited for trolleys and carriages. The tracks were elevated, as shown on the left and in the rear, creating a barrier between the center city and the Ironbound section, so named because it was bound by the iron railroad tracks.

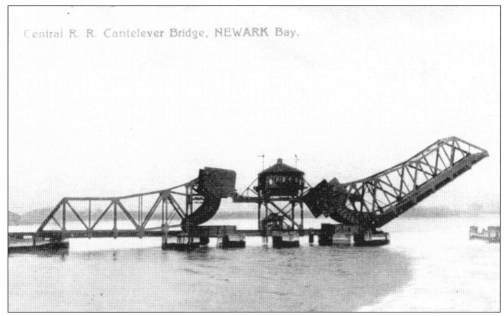

The Central Railroad's Newark Bay Bridge is a cantilever-type bridge. East of the Singer Sewing Machine Company plant in Elizabeth, the railroad cut across the bay to Bayonne, two miles away. Although the bridge improved train service, it was difficult for ships to pass through the draws and the railroad had to hire tugboats to assist the ships.

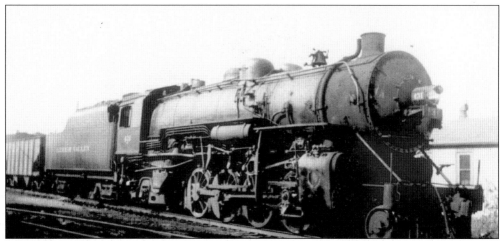

Lehigh Valley Railroad Engine 431 roars through Newark. The Lehigh Valley began operation in 1891. It discontinued passenger service on May 29, 1948, but continued to operate freight trains. Passenger service resumed on the tracks when the Aldene Plan was implemented on May 1, 1967, and the Jersey Central Railroad trains were transferred to the Lehigh tracks at Aldene in Roselle Park. All of the railroads became part of Conrail on April 1, 1976. Service within the state is conducted today by New Jersey Transit.

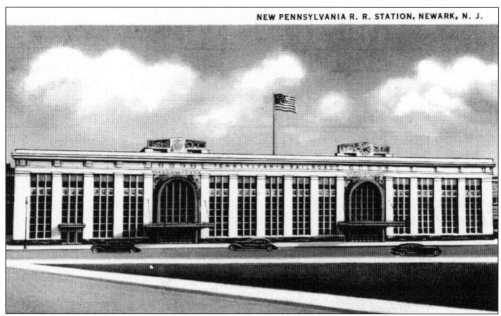

The present Pennsylvania Station opened for business in March 1935. The Art Deco structure was restored to its original beauty in 2000. Although the Pennsylvania Railroad no longer operates, the building continues to be called the Penn Station.

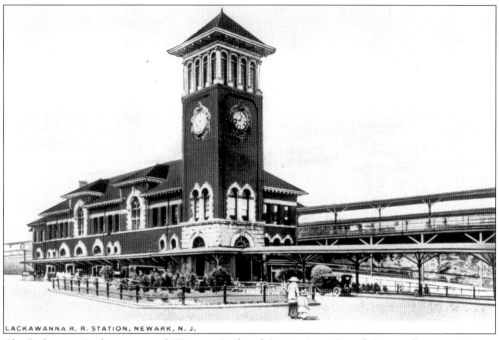

LACKAWANNA R. R. STATION, NEWARK, N. J.

The Delaware, Lackawanna and Western Railroad Station is on Broad Street adjacent to Route 280. Many commuters take the passenger train from stops in Morris and Essex Counties to Newark and walk along Broad Street to their offices or universities. The Delaware, Lackawanna and Western became the Erie Lackawanna in October 1960. Although restored, the station appears the same as when it opened.

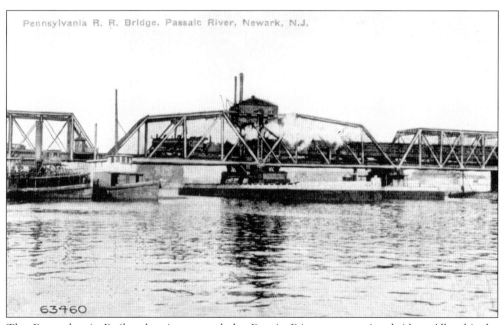

Pennsylvania R. R. Bridge, Passaic River, Newark, N.J.

63460

The Pennsylvania Railroad trains crossed the Passaic River on a swing bridge. All vehicular bridges over the Passaic River in Newark permit ships to pass underneath them.

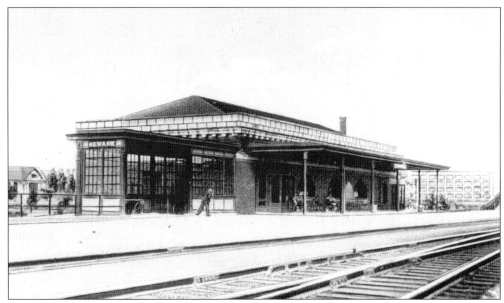

This Lehigh Valley Railroad Station stood in Weequahic Park near Meeker Avenue. The station was used for passenger service until May 29, 1948. Passenger service returned to the tracks in 1967, but the Central Railroad of New Jersey trains failed to stop at this station. Later, it was removed. A train traffic tower above the tracks on Meeker Avenue in Newark ceased operation in 2003.

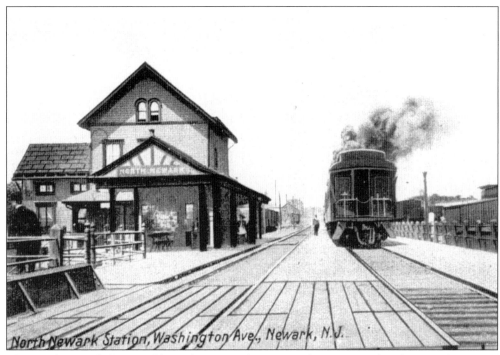

The North Newark Station of the Delaware, Lackawanna and Western Railroad was on the present Broadway, then known as Washington, Avenue. It was one of seven railroad stations in Newark.

Four

POLITICAL PALACES

The 19th century inspired Newarkers to build public buildings of beauty as well as usefulness. Nationwide architects were sought to design the structures. Granite, marble, and brownstone were used to enhance them. The architects vied with each other, designing in the most popular styles, including Egyptian, Greek Revival, Gothic, Federal, Romanesque, Italianate, Victorian, Richardsonian, Beaux-Arts, and Classical Revival—sometimes combining elements of several styles. Each architect attempted to outdo the others. Columns and roofs were the most dramatic exterior design. The interiors featured marble floors and graceful staircases, large murals, and handsome chandeliers.

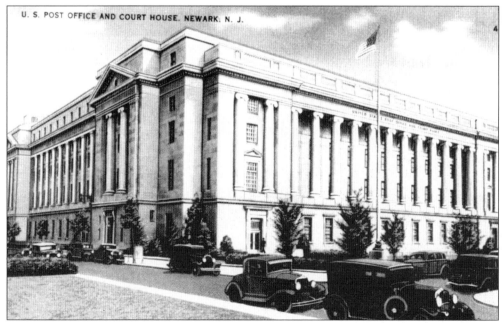

The U.S. Post Office and Federal Courts Building, on Walnut Street, replaced the old post office beside the Morris Canal in the late 1920s. Since its construction, additional buildings have been erected, and the area is now known as Federal Square.

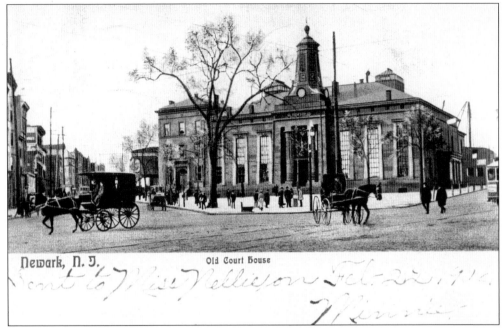

Newark, N. J. Old Court House

In 1837, Philadelphia architect John Haviland designed this Egyptian-style building to house the governments of both Essex County and the city of Newark. A decade later, the city government moved from building to building until the present city hall was completed in 1906. An earlier courthouse was destroyed by fire in 1836.

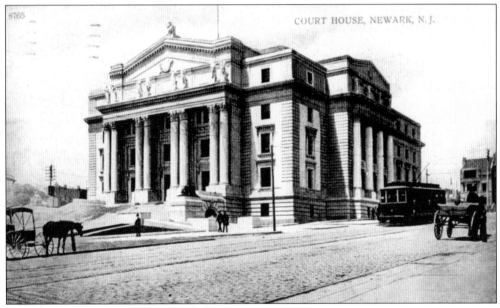

COURT HOUSE, NEWARK, N. J.

Well-known architect Cass Gilbert designed the 1907 Essex County Courthouse, which is still being used. The courthouse was built behind the 1837 building. Set on a hill just below High Street, it rises above Market Street. Its main doorway is reached by a series of steps leading up to three doors flanked by eight Corinthian columns. The building features a group of 11 marble figures by Andrew J. O'Connor Jr. It is currently undergoing restoration.

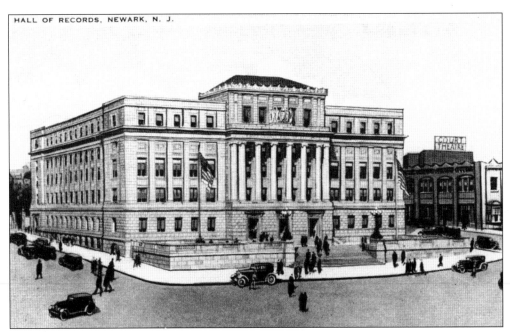

To house the county's records, the Essex County Hall of Records was completed in 1927 adjacent to the courthouse.

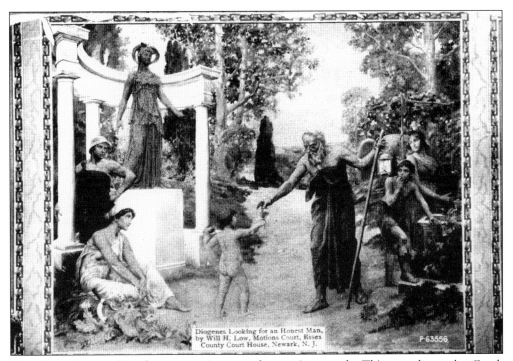

Diogenes Looking for an Honest Man, by Will H. Low, Motions Court, Essex County Court House, Newark, N. J.

P-63556

The Essex County Courthouse contains several attractive murals. This one shows the Greek philosopher Diogenes looking for an honest man. The mural was painted by Will H. Low. It is in the Motions Court area.

49

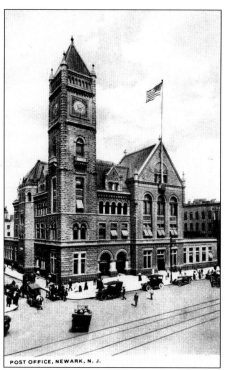

POST OFFICE, NEWARK, N. J.

The old U.S. Post Office was on Broad Street at the Morris Canal. It featured a tall tower with a clock. The canal went under Broad Street at this site. The canal ceased operation in 1924, and it became Raymond Boulevard in 1932.

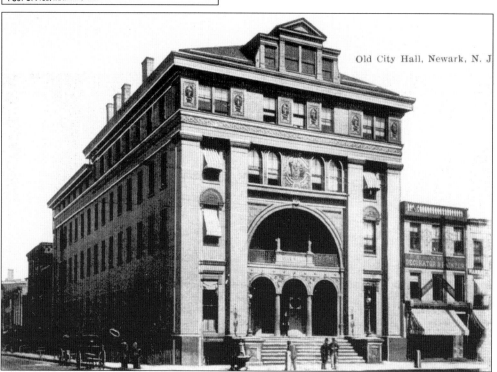

Old City Hall, Newark, N. J

In 1863, the city government moved into the MacGregor House, a converted hotel at the corner of Market and William Streets. It was the 10th time the government had moved over the years. By the 1890s, city officials began to think about constructing a new building.

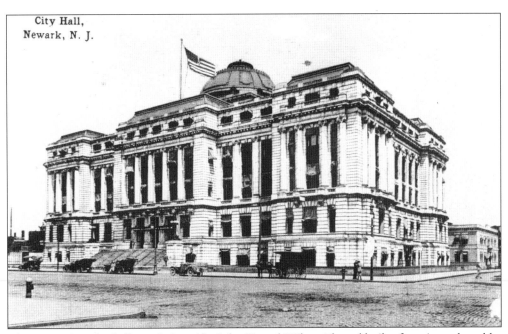

City Hall,
Newark, N. J.

The Beaux Arts city hall was designed by John H. and Wilson Ely and built of granite and marble. Begun in 1903, it was completed in 1906.

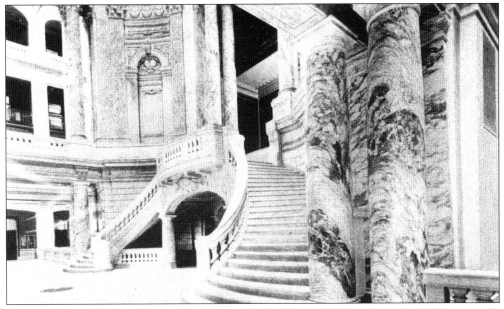

The city hall features curved marble staircases, Doric pillars and balconies, and a 70-foot rotunda on the main floor. The building is topped by a round gold dome. It is frequently used as a setting for motion pictures.

John H. Ballantine, eldest son of brewery operator Peter Ballantine, purchased the mansion at 43 Washington Street, which became known as the Ballantine Mansion. In 1937, the mansion was purchased by the Newark Museum for offices. In 1976, it was restored to its original beauty and opened to the public. The mansion was designed by architect George E. Harney in 1883–1885. It is notable for its red brick and gray Wyoming sandstone, its carved floral and foliate designs around the top of the porch end, and its Corinthian pillars.

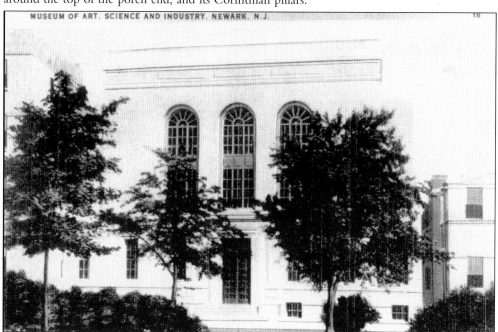

John Cotton Dana founded the Newark Museum on the fourth floor of the Newark Public Library in 1909. The exhibits quickly outgrew the library space, and Louis Bamberger volunteered to provide funds for the new museum, a limestone building with brass doors. The building was erected in 1926 on the site of the home of Marcus Ward, a former governor.

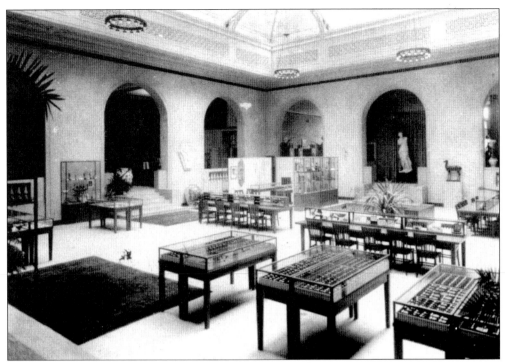

Exhibit cases lined the courtyard of the Newark Museum shortly after it opened in 1926. Since then, the area has been used for lectures, concerts, lunches, and children's programs.

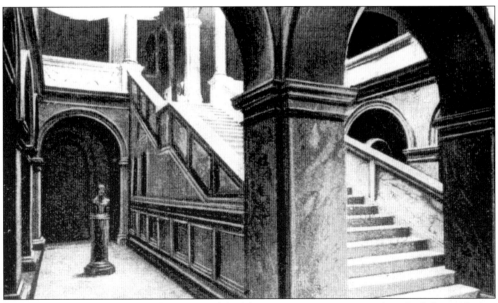

This marble staircase went up the center of the library atrium. It was moved to the left rear during alterations between 1950 and 1952. The library is a copy of the Palazzo Strozzi in Florence, Italy, designed by Benedetto Da Malano in 1489. Rankin and Kellogg, an architectural firm in Philadelphia, prepared the plans. In 2003, a major renovation and expansion of the building to Essex Place began.

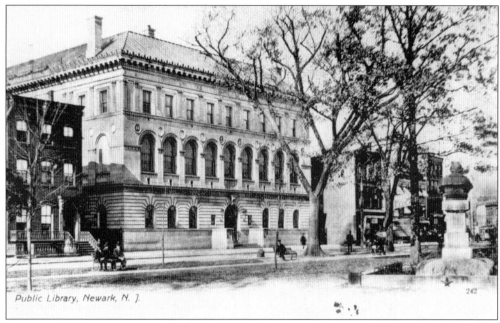

Public Library, Newark, N. J.

The Newark Public Library was founded in 1889, in a building on West Park Street. It developed from the old Newark Library Association formed in 1845. It occupied Library Hall with the post office, the New Jersey Art Union, the New Jersey Historical Society, the New Jersey Natural History Society, and the YMCA and charged its subscribers $3 annually to borrow two books at a time. An 1884 state law permitted the establishment of free public libraries. In 1887, Newarkers approved a referendum establishing a library. This building was erected in 1901. It stood among mansions at 5 Washington Street. A bust of Dr. Abraham Coles, by John Quincy Adams Ward, stands in Washington Park at the right. Dr. Coles was the president of the New Jersey Medical Society.

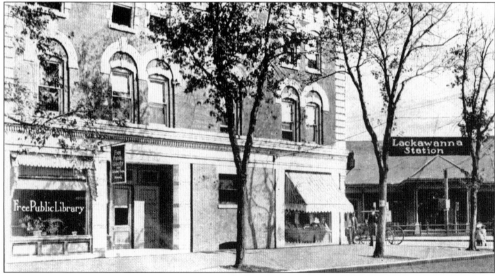

The Roseville Avenue branch of the Newark Public Library was housed in a storefront at 417 7th Avenue at 9th Street. Mrs. J.A. Dunham was the librarian. Note that the Lackawanna Railroad Station is in the right rear.

54

Five

KEEPING THE CITY SAFE AND HEALTHY

When Newark was settled, there were no public services except those provided by the families and neighbors. As the hamlet became larger, a constable was appointed to enforce the law and, when it appeared necessary, a night watchman was appointed to patrol the streets. The police department was developed when Newark became a city in 1836.

Fire protection depended upon the bucket brigade. Men and boys from the hamlet lined up between the fire and the water source (the Passaic River, a well, a swamp, or a pond) with buckets. The man at the water source filled a bucket and passed it down the line to the man nearest the fire, who then poured the water on the flames. It was a long, slow, and hot process that was not too successful. Eventually, volunteer fire companies were formed—first, with hand pumpers for the water and, later, with steam-operated pumpers. Finally, fire hydrants were installed along the streets and the formal department was organized.

The care of the sick evolved slowly. Initially, all sick people were taken care of in their homes by family members. During Revolutionary times, physicians believed in bleeding their patients. Some informal hospitals developed during the war but ceased operation at the war's end. During the Civil War, inoculations for various diseases were administered and the Marcus Ward Hospital opened, but for the war years only. After the war, numerous hospitals opened, especially during Newark's golden age.

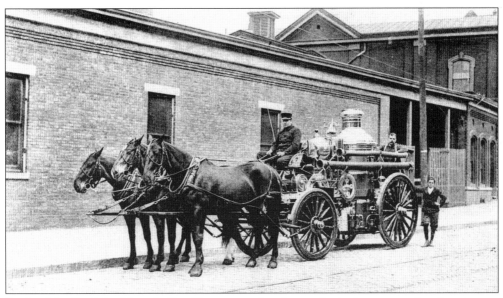

Engine No. 7 of the Newark Fire Department has front wheels that are smaller than its rear wheels. Like the other steam engines, it is pulled by three horses. Note that the youth at the rear of the engine is wearing knickers, once a very popular garment for boys. A second fireman is seated behind the steamer.

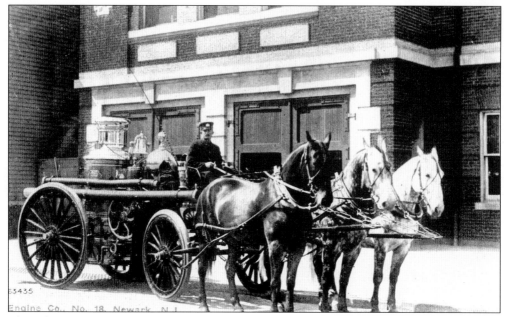

Three horses are used to pull this steam engine operated by Engine Company No. 3 of the Newark Fire Department in 1905. The number of departments varied from time to time.

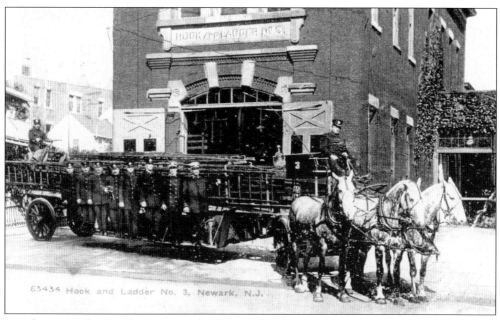

Ten firemen gather on the engine to have their photograph taken in front of Hook and Ladder Company No. 3. The man seated at the right drives the three horses while the man seated in the back guides the rear of the long engine around corners.

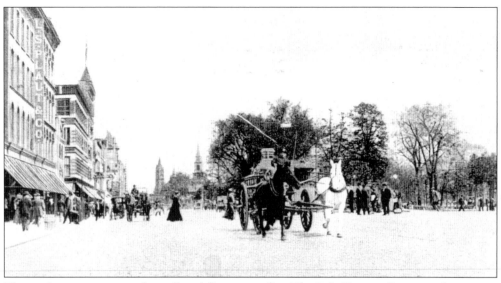

The engine steamer races down Broad Street to a fire. The L.S. Plaut & Company department store is on the left, and Military Park is on the right.

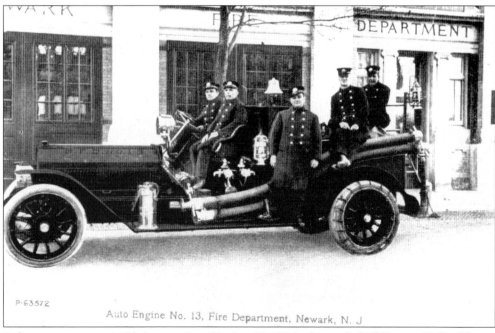

P-63572

Auto Engine No. 13, Fire Department, Newark, N. J

A fire company poses with its new Auto Engine No. 13 in front of a building on Holland Street and Summer Avenue. Motorized vehicles such as this engine began replacing the horse-drawn equipment in 1911.

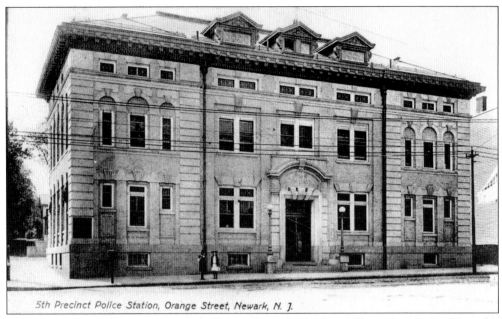

5th Precinct Police Station, Orange Street, Newark, N. J.

The 5th Precinct Police Station was on Orange Street in the Roseville section during Newark's golden age. For many years "Marty," an Irish policeman from the precinct, protected schoolchildren at the Roseville Avenue pedestrian crossing.

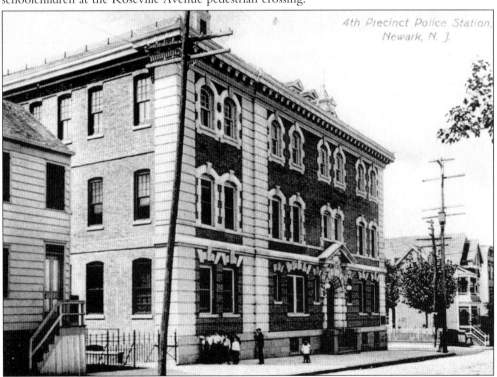

4th Precinct Police Station, Newark, N. J.

These children are apparently having their picture taken in front of the 4th Precinct Police Station. Note the old house on the left. It is typical of the early single-family dwellings in the center of the city.

The Newark Salvage Corps was a unit separate from the police and fire departments in the early 20th century.

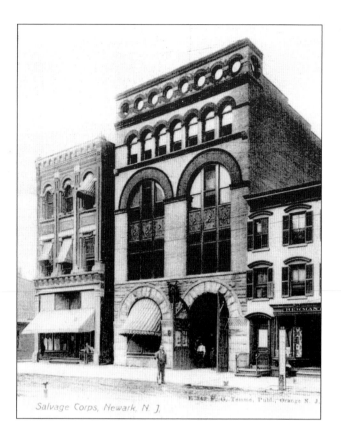

Salvage Corps, Newark, N. J.

Police headquarters in the early 20th century resembled the precinct buildings.

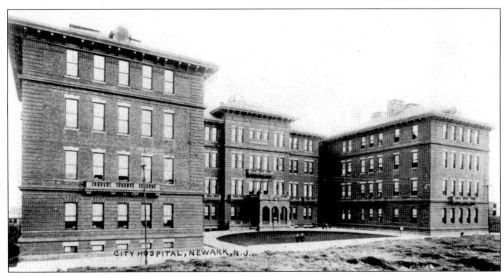

The Newark City Hospital was opened in the almshouse after it was organized in 1882. For many years in the early 1900s, it was considered to be a charity facility devoted to the poor. It was replaced by Martland Medical Center, which was built beside it in the mid-1950s.

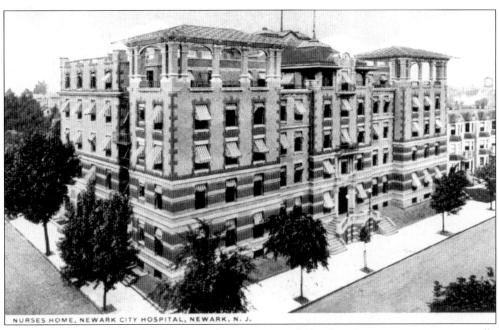

This is the nurses' home for the Newark City Hospital. At that time, nurses were generally housed in old Victorian mansions.

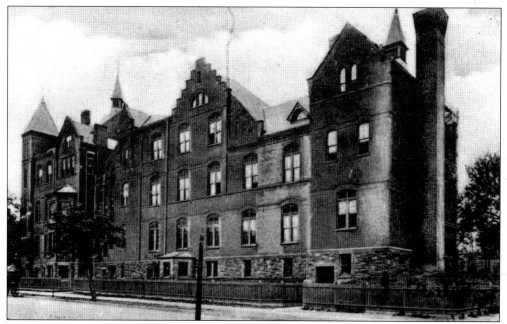

St. Barnabas Hospital opened on High Street after the Civil War. It was staffed by Episcopalian nuns, who, in time, were replaced by regular nurses. The hospital moved to Livingston in the 1960s and affiliated with the United Hospital, the Children's Hospital, and the Beth Israel Medical Center, all of Newark, as well as with Union Hospital in Union Township, Irvington General Hospital in Irvington, and others.

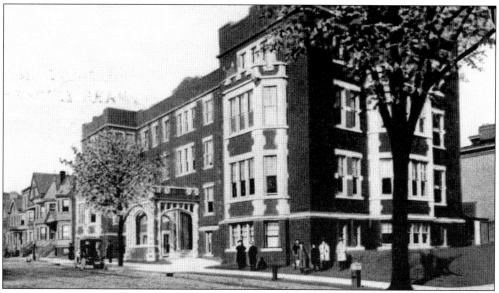

The Beth Israel Hospital in Newark was formed in 1901 by the merger of two Jewish women's groups: the Daughters of Israel Association and the Hebrew Hospital and Dispensary Association. Beth Israel used a house with 21 beds on High and West Kinney Streets until it constructed this larger building by 1905. By 1923, when construction began on the present hospital on Lyons Avenue at Osborne Terrace, there were 110 beds. The 12-story tower of the 1928 hospital became a landmark for the Weequahic section of Newark after the hospital opened.

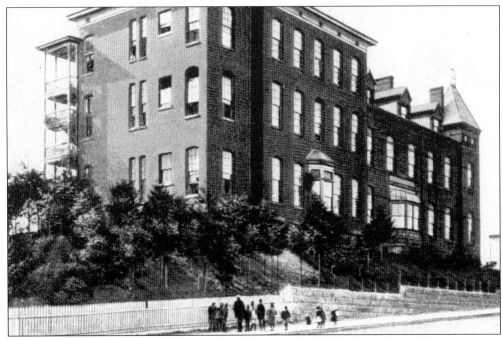

The German Hospital was founded in 1857. Construction of the building was begun in 1869, and an addition was added in 1887. The hospital had several names. At one time, it was known as the Lutheran Hospital, since most of its patrons were Lutheran. After former nursing school student Clara Maass made the supreme sacrifice during the Spanish-American War in Cuba, hospital authorities named the institution after her. The hospital is now in a new building in Belleville.

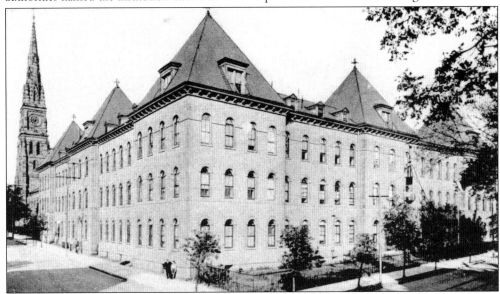

St. James Hospital (foreground) and St. James Roman Catholic Church (left background) were built to serve the people in the Ironbound section. The church had a large Irish congregation, most of whom moved out of the city during the 20th century. In the 1970s, the hospital replaced the church with a parking lot. In addition to serving Ironbound residents and factory workers, the hospital supplies medical aid to people at the Newark Liberty International Airport.

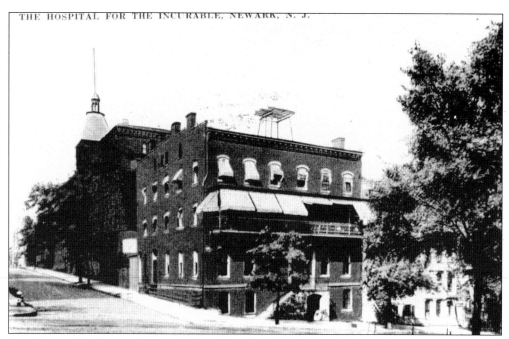

The Hospital for Incurables served those who faced life without hope of living.

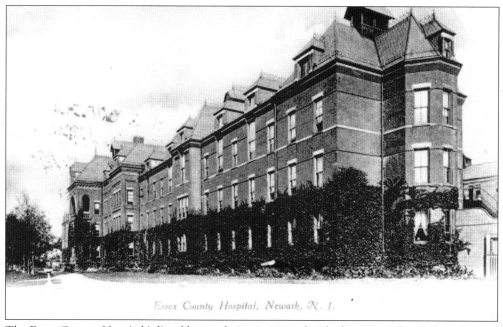

Essex County Hospital, Newark, N. J.

The Essex County Hospital is listed here as being in Newark. The last county hospital was located in Belleville.

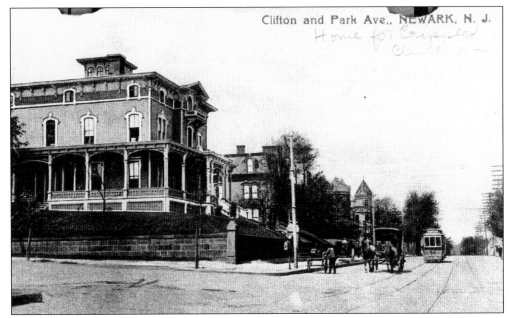

Clifton and Park Ave., NEWARK, N. J.

The large house on the left, on Clifton and Park Avenues, at one time was used as the hospital for crippled children. Note the wagon drawn by two horses and the trolley car. Unlike some streets at this time, there were two sets of trolley tracks so that cars traveling in opposite directions could pass. In some areas, there was only one set of tracks, and there, the driver would have to wait if another trolley was due.

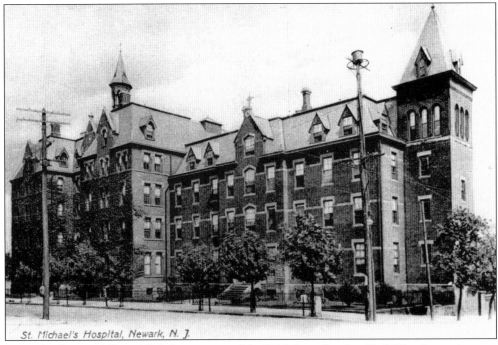

St. Michael's Hospital, Newark, N. J.

St. Michael's Hospital, on High Street, opened in 1866, just after the Civil War. It continues to occupy the same site. It was the first permanent hospital in the city.

64

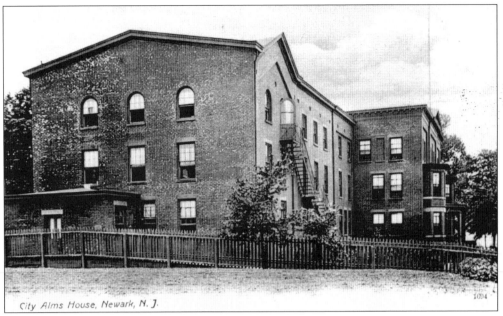

City Alms House, Newark, N. J.

The city's almshouse provided a roof and food for destitute people. Almshouses ceased operation after World War II.

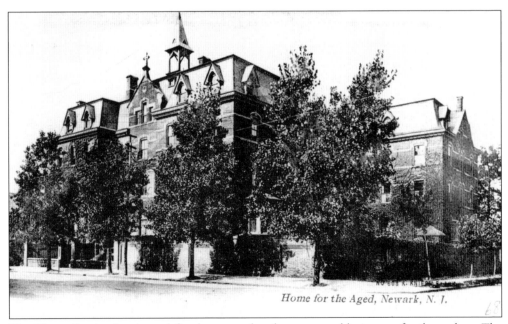

Home for the Aged, Newark, N. J.

The Home for the Aged cared for those people who were unable to care for themselves. The Little Sisters of the Poor operated the home for several years. Later, New Community Corporation renovated the facility for senior citizen housing.

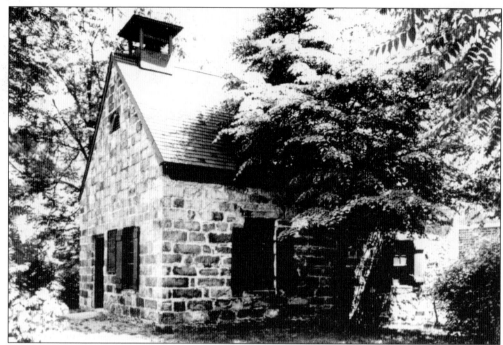

The Lyon's Farms School is the oldest school in Newark. Organized in 1728 at the intersection of the Upper Road to Elizabethtown (Elizabeth Avenue) and Pot Pie Lane (Chancellor Avenue), the school was burned during the Revolutionary War and rebuilt of local stone in 1784. It closed in 1902. The one-room schoolhouse was moved to the garden of the Newark Museum in 1938.

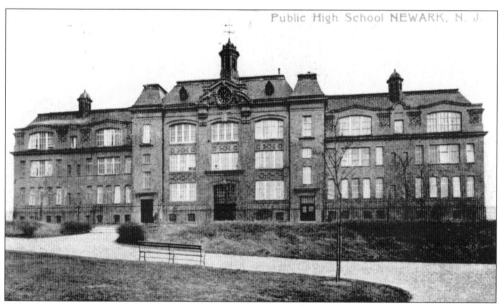

The first high school in Newark opened in 1839. Originally known as the Newark High School, its name was later changed to Barringer High School to honor William Barringer, the superintendent of schools. Since then, three buildings have been erected near Branch Brook Park for Barringer High School.

Six
EDUCATING THE YOUNG

When Newark was founded, the pastors of the Congregational church, such as the Reverends Abraham Pierson Sr. and Abraham Pierson Jr., conducted classes in their parsonages. In November 1676, the town council approved the hiring of a schoolmaster and the charging of a fee for children who attended. Newark Academy began in 1774, and after the Revolutionary War, several other private schools opened. Some families hired private tutors for their children.

The city charter of 1836 provided for a free school, but free education was considered to be for the poor only. Free schools began to appear in 1845, and nine years later, more than half the children in the city were enrolled. Night classes were begun for boys who worked, and teachers were given training on Saturdays. Newark was one of three sites in New Jersey selected for a state-operated two-year teacher training school. The other sites were Trenton and Paterson. Gradually, the length of the course was extended to four years, and graduates were awarded a bachelor's degree.

At first, most children went only to the elementary schools. Very few went on to the single free high school in the city. As the population expanded, more schools were needed and additional buildings were erected. By the 20th century, all children were encouraged to attend school. During the Depression, adults took jobs usually held by boys, and as a result, many teenagers remained in high school until they graduated. The G.I. Bill, adopted after World War II, caused college enrollments to increase dramatically.

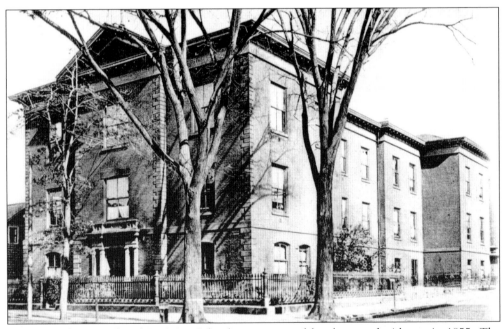

The Newark Normal and Training School was approved by the state legislature in 1855. The training course was two years long. In mid-1934, the course was extended to four years and bachelor's degrees were awarded. In 1958, the Newark State College moved to a new campus at Green Lane Farm in Union Township, the former home of Rep. Hamilton Fish Kean. Today, the college is a university named for the Kean family.

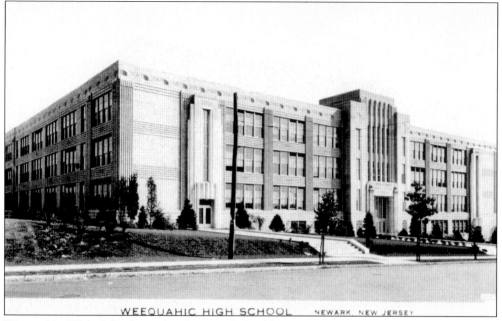

WEEQUAHIC HIGH SCHOOL NEWARK, NEW JERSEY

Weequahic High School, an Art Deco–style building, was opened in 1933. Because of the student population, it became known as the city's Jewish high school. After the civil disturbances of 1967, the area became mostly African American.

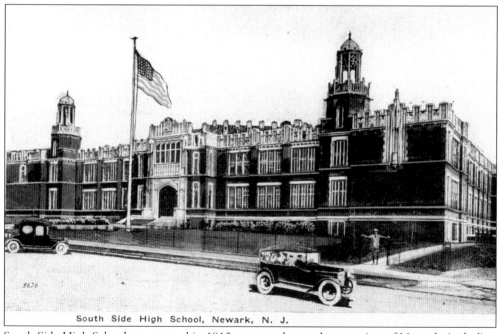

South Side High School, Newark, N. J.

South Side High School was erected in 1913 to serve the southern section of Newark, including Clinton Hill and Lyon's Farms (Weequahic). After 1920, the school attracted many Jewish students and, until Weequahic High School opened, was known as the Jewish high school of Newark.

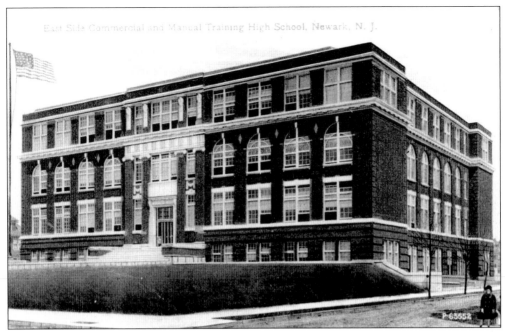

The East Side Commercial and Training High School opened in 1912 in the Ironbound section. Later, it became just East Side High School. It offered college preparatory courses, too, and several students from other areas attended the school each year.

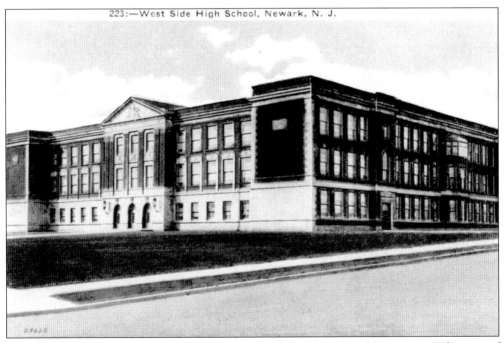

223:—West Side High School, Newark, N. J.

West Side High School, which opened in 1926, needed a 15-room addition in 1929 because of the population increase in the area. Many students from the Weequahic section traveled to it because it was new and Weequahic High School was not available. West Side was built to serve the Roseville and Vailsburg sections of the city.

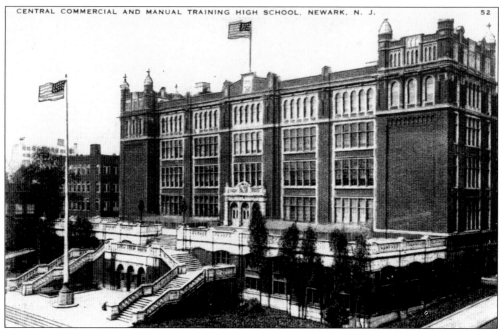

Central Commercial and Manual Training High School offered specialized courses when it first opened in 1912 on High Street next to Newark Technical School. Courses were work oriented.

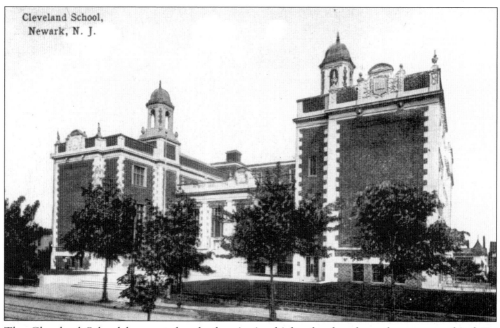

Cleveland School, Newark, N. J.

The Cleveland School has served as both a junior high school and an elementary school. Its appearance is the same today as it was when this picture was taken.

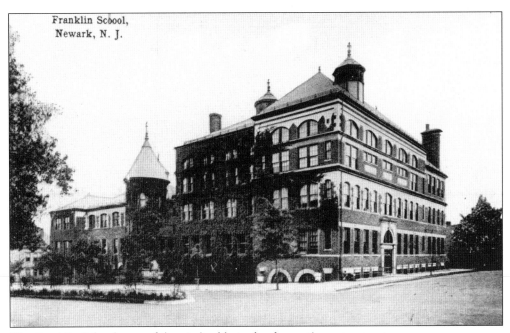

The Franklin School, one of the city's oldest schools, continues to operate.

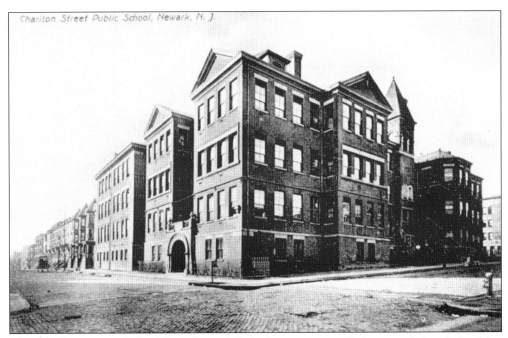

The Charlton Street School has changed little in appearance. It is one of the city's oldest buildings. It is in the Central Ward.

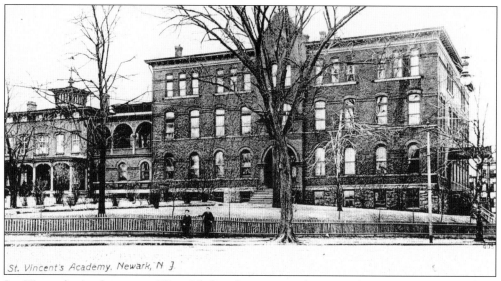

St. Vincent's Academy, Newark, N.J.

St. Vincent's Academy, on West Market Street, provides secondary education to Roman Catholic girls. The Sisters of Charity continue to operate the school. Originally, it was attended mostly by girls from Irish families. Today, many of the students are African Americans. St. Vincent's Academy is undergoing extensive renovations.

Newark Academy was begun in 1774 on present-day Washington Park. It was burned during a raid on January 25, 1780. It was rebuilt on Academy Street after the Revolutionary War. It occupied the Wesleyan Institute, on High Street, in 1850. Later, it occupied this building, on First and William Streets, before it moved to Livingston in 1964.

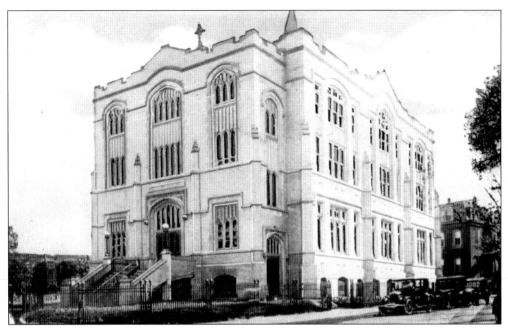

St. Rose of Lima Parochial School was organized in 1907. Ceremonies were conducted on Palm Sunday 1906 to install the cornerstone. The school building, on Orange Street, opened in 1909. An addition was built on the front of the school sometime after this photograph was taken.

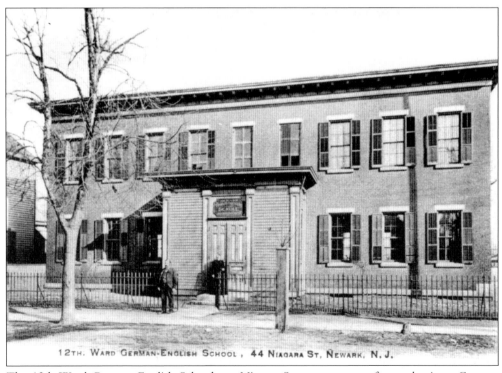

12TH. WARD GERMAN-ENGLISH SCHOOL, 44 NIAGARA ST, NEWARK, N. J.

The 12th Ward German English School, on Niagara Street, was one of several private German language schools in the city that preserved German culture while acclimating children to America.

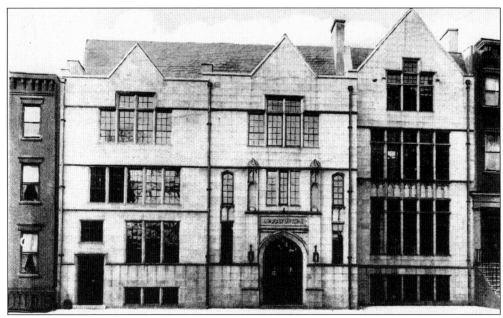

The New Jersey Law School opened early in the 20th century. Today, the city has two law schools: Rutgers University and Seton Hall University. In 1930, the New Jersey Law School began a pre-legal department called Dana College, named for John Cotton Dana, former director of the Newark Public Library. Following two mergers, the New Jersey Law School became Rutgers University Law School.

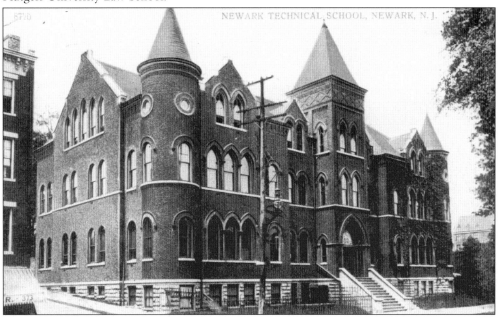

Founded in 1884, the Newark Technical School became the Newark College of Engineering in 1919 and the New Jersey Institute of Technology in the 1990s. If plans go as Gov. James McGreevey would like them to, Rutgers University, the New Jersey Institute of Technology, and the University of Medicine and Dentistry will become one college. Currently, students in any of these three institutions may take courses for credit in the other two colleges.

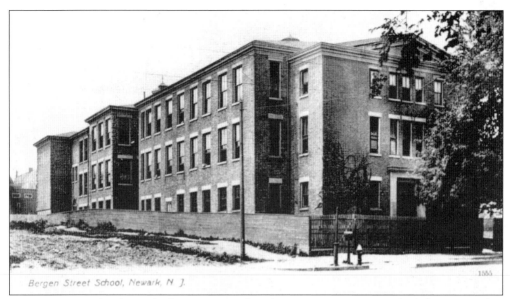

Bergen Street School was built in 1900. After the remaining section of Clinton Township merged with the city in 1902, the school served the Weequahic Park section until additional schools were built in the 1920s. The school is now the William Brown Academy.

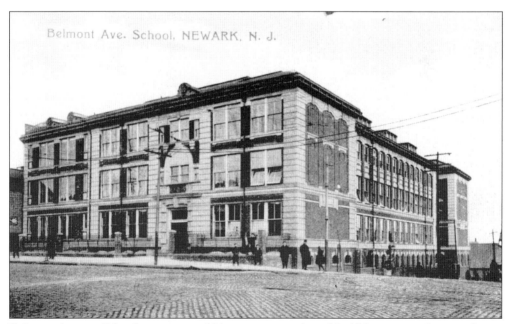

Belmont Avenue School was on a cobblestone street when this 19th-century photograph was taken. The street name was changed to Irvine Turner Boulevard. Now gone, the school was replaced by the Belmont-Runyon School, built in 1962.

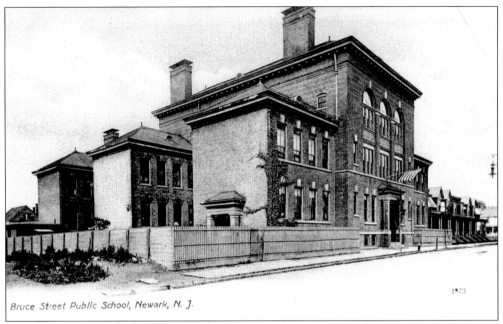

Bruce Street Public School, Newark, N. J.

Bruce Street Public School was situated close to the curb. Like several other schools in the city, there was no place to play or conduct outdoor gymnasium activities. The school was razed.

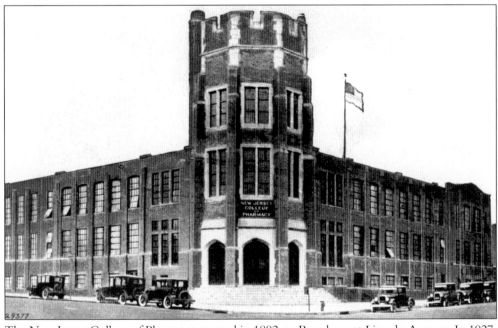

The New Jersey College of Pharmacy opened in 1892 on Broadway at Lincoln Avenue. In 1927, the college became part of Rutgers University, with the name Rutgers College of Pharmacy. In 1946, Rutgers University took control of Newark University and pharmacy became a major course. This building is now a police complex.

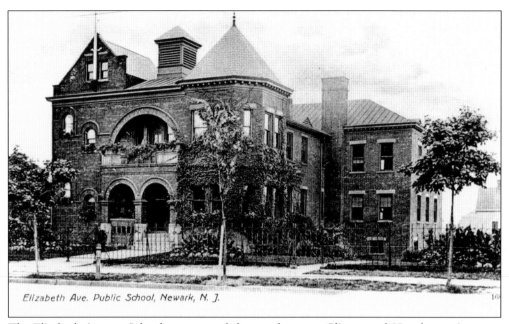

Elizabeth Ave. Public School, Newark, N. J.

The Elizabeth Avenue School once served the area between Clinton and Hawthorne Avenues. It was razed when newer buildings were erected.

Ann Street, Public School, Newark, N. J.

The Ann Street School served the area near Independence Park, in the Ironbound section.

The Abbington Avenue School was off Bloomfield Avenue near Branch Brook Park in the North Ward.

The Avon Avenue School was erected *c.* 1907, to provide education for children in the new Clinton Hill section that was then being developed in Newark. The school continues to function.

Seven
THE ECCLESIASTICAL ARCHITECTURAL HERITAGE

Newark was known as the City of Churches. At one time, there were 22 Presbyterian churches, 36 synagogues, at least one church for each Roman Catholic ethnic group, and regular parish churches. The relationship among all the churches, synagogues, and ethnic groups remained pleasant. However, family relationships, languages, food, customs, and cultural preferences tended to keep ethnic groups together. By the beginning of the 20th century, different sections of the city began to be known for their predominant populations, which included Brazilians, Greeks, Chinese, Germans, Italians, Jews, Russians, Poles, Portuguese, and African Americans.

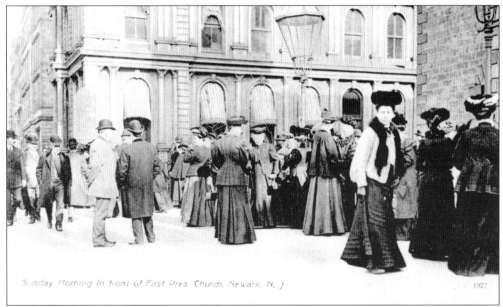

Sunday Morning In front of First Pres Church, Newark, N. J 1927

Members of the congregation of the First Presbyterian Church gather in front of the church after a Sunday morning service to chat with friends. Note the large hats and gowns that the women are wearing. They were considered to be the height of fashion in the golden age. The church, founded in 1666, is the oldest in the city. It started as a Congregational church and became Presbyterian in 1717.

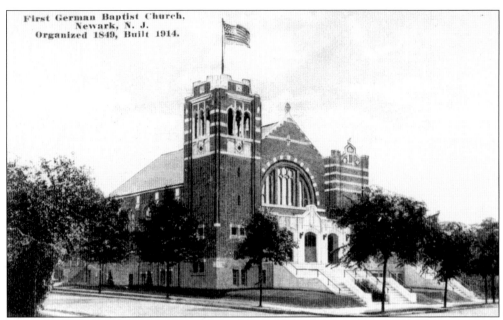

First German Baptist Church,
Newark, N. J.
Organized 1849, Built 1914.

The First German Baptist Church organized in 1849. It purchased the former sanctuary of the First German Presbyterian Church, at 24 Mercer Street, in 1881. This church was erected in 1914 at the same site. Germans started settling in Newark prior to the Revolutionary War. Many of the Hessian soldiers stayed in the new country at the war's end. In the 1840s, additional Germans began migrating to the city. In addition to churches and schools, the Germans had singing societies and bands.

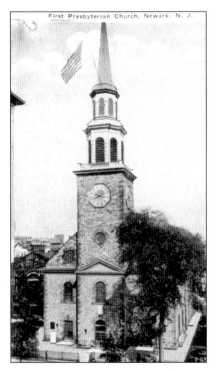

First Presbyterian Church, Newark, N. J.

Newark was a theocracy when it was settled by Congregationalists from New Haven, Connecticut. Only church members were permitted to hold office or vote. The church became Presbyterian in 1717. It was burned during the Revolutionary War, and this building was erected near the Four Corners, at Broad and Market Streets.

The Fifth Presbyterian Church was formed in 1848. It became the Park Presbyterian Church before it closed.

5th Ave. Presbyterian Church, Roseville, Newark, N. J.

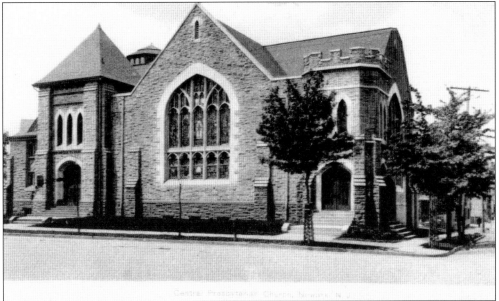

The Central Presbyterian Church was begun in 1837 on Washington Street. In 1896, construction of the present church began in the Clinton Hill area, on Clinton Avenue at Belmont Avenue (now Irvine Turner Boulevard). A fire in the 1990s nearly destroyed the building. The congregation met in the defunct Second Presbyterian Church until the church was rebuilt. Worship resumed at the Clinton Hill site in 2000.

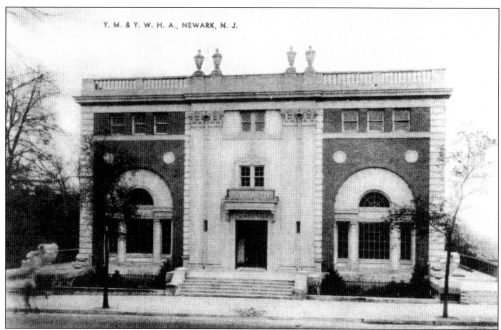

The Young Men's and Young Women's Hebrew Association was built on High Street (now Rev. Dr. Martin Luther King Boulevard) in 1924. It rapidly became a cultural and community center for the Jewish population, hosting lectures, concerts, and plays. Many actors and actresses honed their skills in productions at the center.

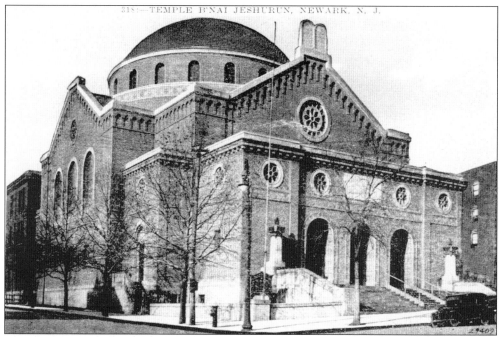

TEMPLE B'NAI JESHURUN, NEWARK, N. J.

The B'nai Jeshurun congregation built this beautiful structure on High Street in 1914. By that time, the synagogue had become a Reform congregation. In 1968, the congregation moved to Short Hills. The Hopewell Baptist Church and several agencies now occupy the building.

B'nai Jeshurun was the first synagogue in Newark. It was organized in 1847 as an Orthodox congregation in the Washington Street home of Isaac Cohen. It later became a Reform congregation. The synagogue occupied this building on Washington Street from 1881 to 1914, when it moved into its new sanctuary on High Street. In 1968, the congregation moved to Short Hills.

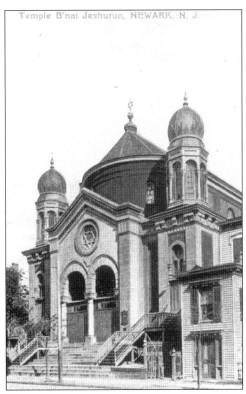

Temple B'nai Jeshurun, NEWARK, N. J.

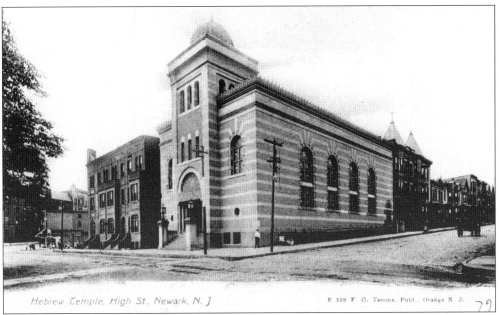

Hebrew Temple, High St., Newark, N. J. E 359 F. G. Temme, Publ., Orange N. J.

Congregation B'nai Abraham, founded in 1855 by Abraham Newman, eventually became the fourth oldest synagogue in the nation. In 1897, it occupied this building on High Street at 13th Avenue. In 1911–1914, the congregation built a large temple at South 10th Street and Shanley Avenue in the Clinton Hill section. The High Street building was used by St. John's Methodist Episcopal Church and was later razed for an Essex County Courthouse parking lot.

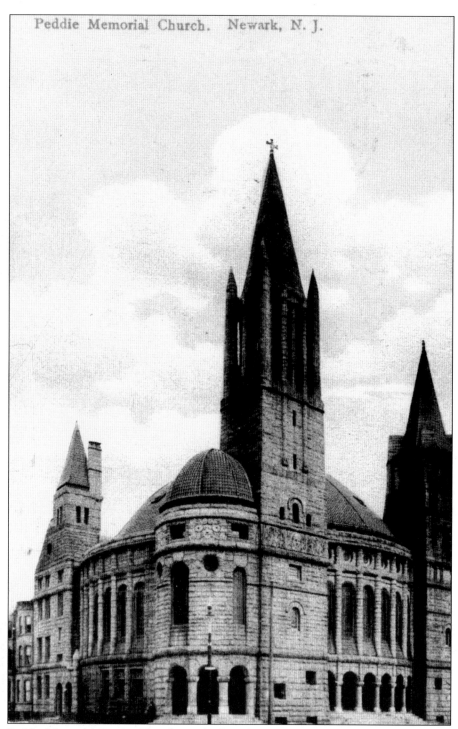

Peddie Memorial Church. Newark, N. J.

The Peddie Memorial Baptist Church was built at the request of Mrs. Thomas Baldwin Peddie in memory of her husband, Thomas Peddie, a mayor and manufacturer of trunks and traveling bags. It is one of the most outstanding sanctuaries in Newark, with 173 stained-glass windows, 200 doors, a circular auditorium with rich paneling, and an 80-foot-high dome.

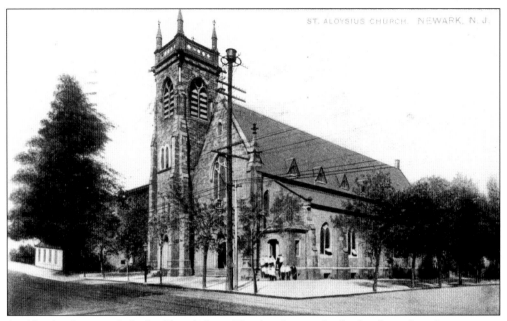

St. Aloysius Roman Catholic Church is on Fleming Avenue in the Ironbound section.

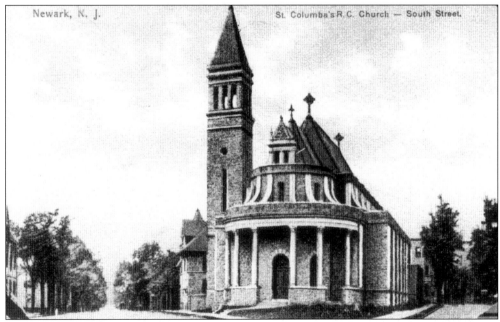

St. Columba Roman Catholic Church, on Pennsylvania Avenue and Brunswick Street, was erected in the 1890s by Irish immigrants. The unique structure was designed by architect Charles Edwards and includes both French and Italian elements. It is known for its tall bell tower and columned portico. Since *c.* 1970, the church has served a large Hispanic congregation. It operates an elementary school and conducts many social service programs in the area near Lincoln Park.

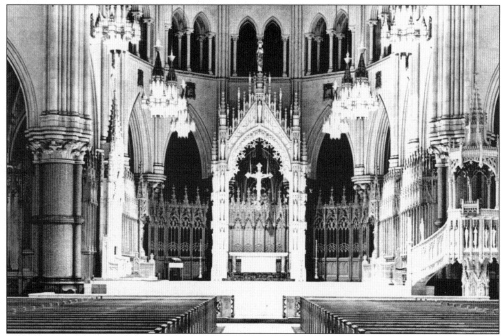

The Basilica Cathedral of the Sacred Heart, the fifth largest cathedral in the United States, is now the seat of the Newark Diocese. Sacred Heart took more than 50 years to build. When it opened, it took the place of St. Patrick's Pro-Cathedral as the diocese seat. The main altar above is surrounded by seven chapels.

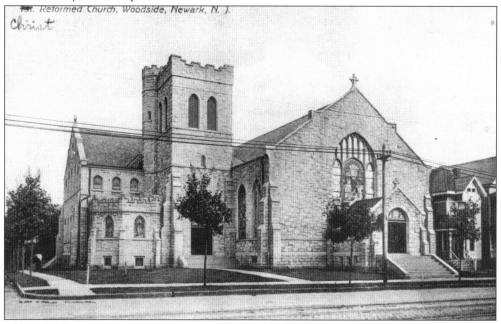

At one time, there were four Dutch Reformed churches in Newark. This one was located in Woodside, once a separate community on the Belleville-Newark border. Woodside became part of Newark in 1871 after only two years as a township. The word "Dutch" was subsequently dropped from the name of the church.

A tall tower once marked the site of the second sanctuary for the Second Presbyterian Church, on Washington Street at James Street. Organized in 1811, three buildings served the congregation. The first church was called the blue church. This building, erected in 1886, burned to the ground. The present building was erected in 1936. It subsequently closed in the 1990s.

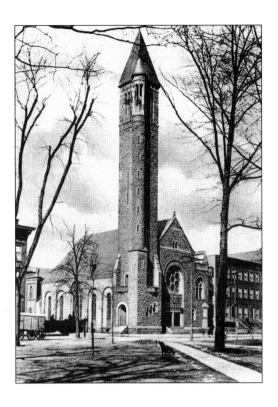

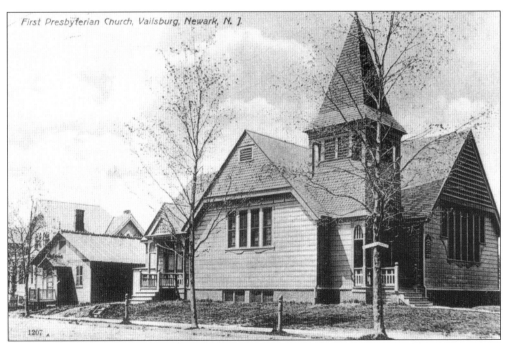

The First Presbyterian Church of Vailsburg began in 1898, shortly before Vailsburg rejoined the city. It became the Kilburn Memorial Presbyterian Church when Vailsburg joined Newark in 1905. The church, located on South Orange and Morris Avenues, has closed.

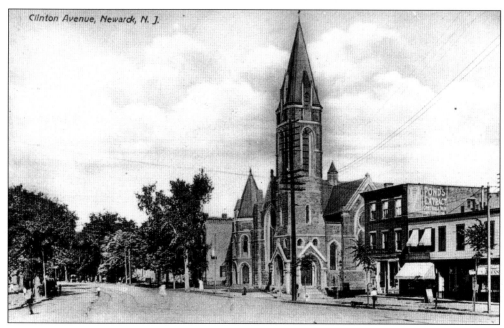

The Clinton Avenue Presbyterian Church agreed to be known as the Third Presbyterian Church South in 1912, when the Third Presbyterian Church, on Broad Street opposite Green Street, voted to disband. The Clinton Avenue congregation soon reverted to its original name. It continues to serve the area.

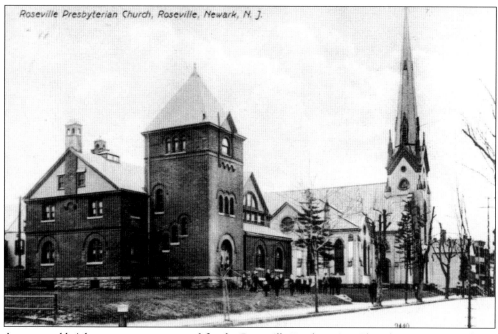

A stone and brick sanctuary was erected for the Roseville Presbyterian Church in 1867. It replaced an earlier frame building built in 1854. The church continues to serve the area. Roseville was the first Newark farmland to be subdivided into house lots outside the center city. It grew rapidly.

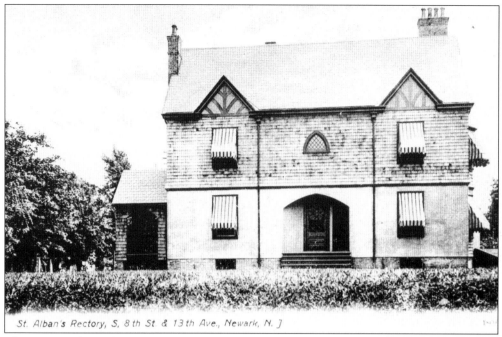

St. Alban's Rectory, S, 8th St. & 13th Ave., Newark, N. J.

The rectory of St. Alban's once stood on South 8th Street and 13th Avenue in Newark.

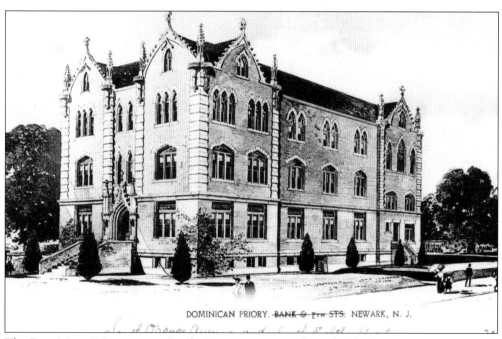

DOMINICAN PRIORY. BANK & 7TH STS. NEWARK, N. J.

The Dominican Priory was on South Orange Avenue and South 8th Street.

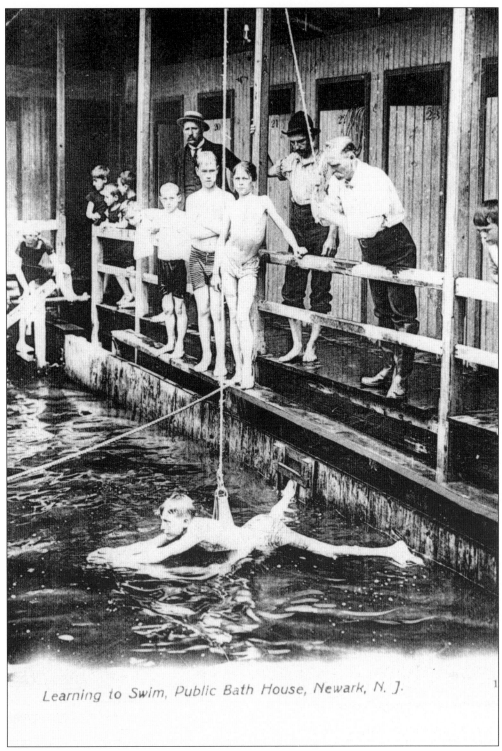

Learning to Swim, Public Bath House, Newark, N. J.

A youngster is attached to a harness in the Learn to Swim program given at a public bathhouse in Newark. Bathhouses took the place of home baths, which many houses in the city lacked.

Eight
A DAY OF RECREATION

While the wealthy were able to take month-long vacations in Florida or on grand tours to Europe, the average person in Newark during the golden age worked five and a half to six days a week. In the day or day and a half they had left, they attempted to crowd all sorts of entertainment—from attending the theater or opera, strolling in one of Newark's beautiful parks, visiting an amusement park, participating in a Saengerfest, visiting friends and relatives, playing tennis, baseball, or croquet, watching the trotters or bicyclists race in Weequahic Park, to just sitting.

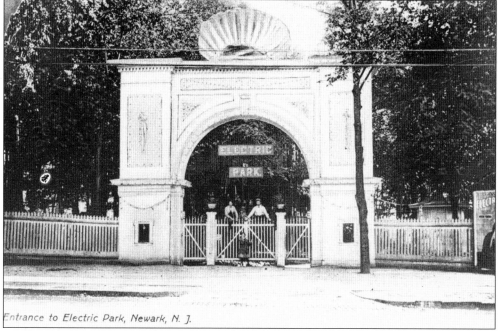

Entrance to Electric Park, Newark, N. J.

This is the entrance to the Electric Park in the Vailsburg section of Newark. It featured rides and other types of entertainment for children and their families.

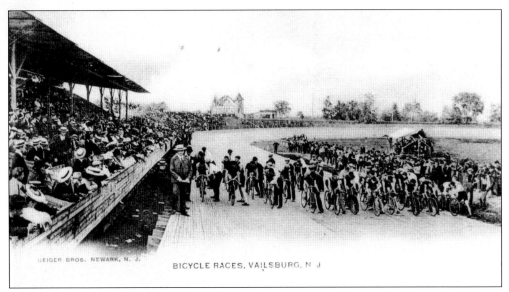

GEIGER BROS. NEWARK, N. J.

BICYCLE RACES, VAILSBURG, N J

Bicycle races became very popular in the early 20th century. A large crowd is attending bike races in Vailsburg Park.

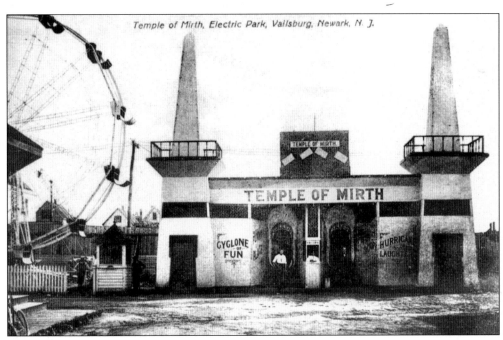

Temple of Mirth, Electric Park, Vailsburg, Newark, N. J.

TEMPLE OF MIRTH

TEMPLE OF MIRTH

CYCLONE OF FUN

HURRICANE OF LAUGHTER

The Temple of Mirth in the Electric Park in Vailsburg provided a Ferris wheel for riding and promised a cyclone of fun and a hurricane of laughter.

The Proctor's Theater, located on Market Street near Washington Street, featured silent motion pictures and vaudeville shows. A pianist played during the movie. The theater was purchased by the Adams family, who also owned the Adams and Paramount Theaters.

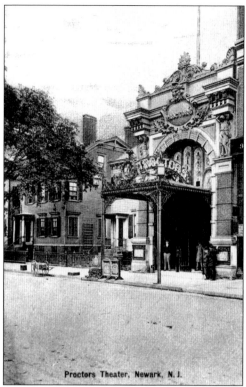

Proctors Theater, Newark, N. J.

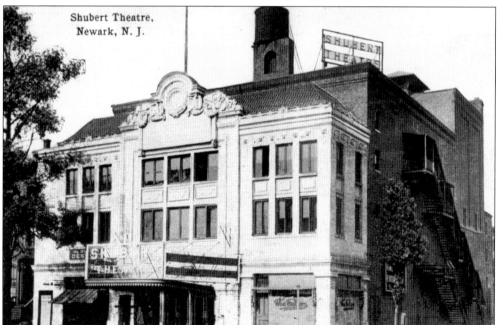

The Schubert Theater, on Branford Place. featured stage shows and vaudeville until 1939, when it was purchased by A.A. Adams, owner of three other Newark theaters. Adams changed the name to the Adams Theater and showed first-run motion pictures. Future stars such as Frank Sinatra appeared at the Adams Theater.

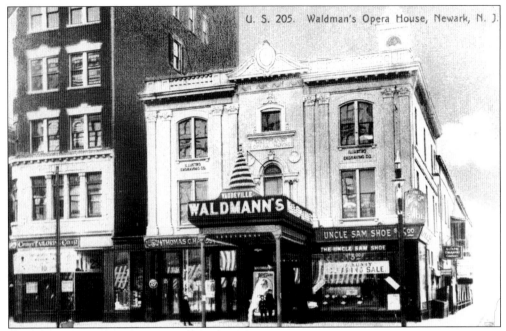

Waldman's Opera House was one of the opera houses in Newark. Another was the Newark Opera House, a block east of the Empire Theater.

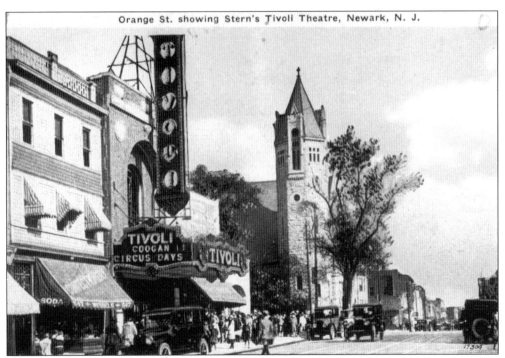

The Tivoli Theater was on Orange Street in the Roseville section. It was one of Newark's many motion picture theaters. The Roseville section also had the Plaza Theater. This postcard announces that the Tivoli is featuring *Coogan's Circus Days,* a vaudeville show.

The Empire Theater on Washington Street presented burlesque shows. Many comics gained experience in burlesque before appearing on the legitimate stage. Entire families attended the shows.

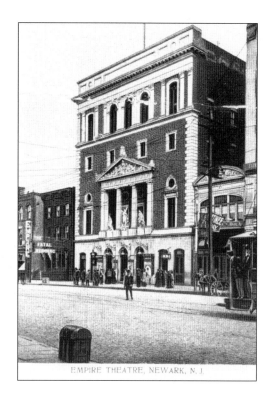

EMPIRE THEATRE, NEWARK, N. J.

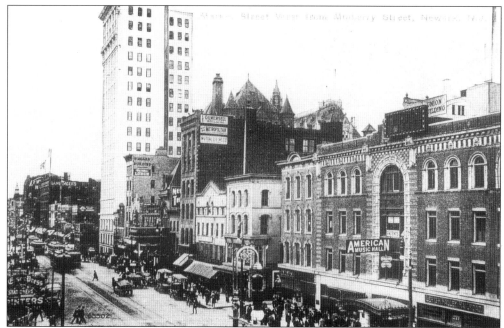

The American Music Hall opened in 1909 in a four-story building at 211 Market Street. It presented vaudeville, burlesque, and motion pictures. Aaron Ordway built the theater and an adjacent office building. The American was renamed the Lyric Theater in 1910. The Newark Evening News purchased the site in 1956 to expand the newspaper plant.

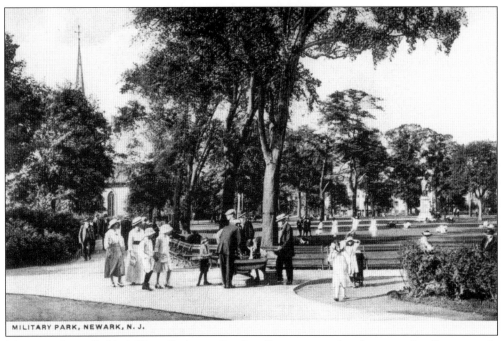

MILITARY PARK, NEWARK, N. J.

Many people strolled in Military Park on a Sunday afternoon to enjoy the sunny day. Some people took longer walks in the city's new residential areas or traveled outside the city to the nearby farms. Walking on a pleasant day was an enjoyable way to spend an afternoon. Note the women are in their Sunday best, with large-brimmed hats and long skirts. The girls are wearing shorter dresses and hats. All the men are dressed in suits and hats, and the boys are in suits and caps.

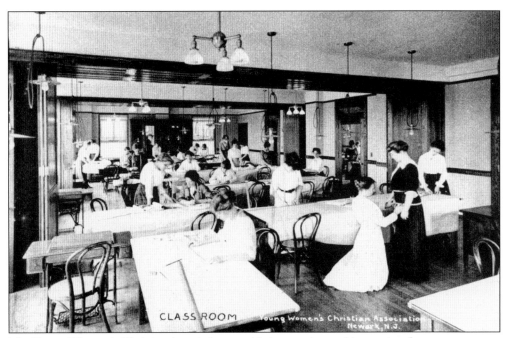

CLASSROOM — Young Women's Christian Association Newark, N. J.

The Young Women's Christian Association provided recreation and instruction for young women. This is a class on dressmaking. Note the kneeling girl who is fitting a dress on her classmate.

The Young Women's Christian Association stood beside the Newark Museum. It provided a home away from home to young women who came to Newark to work in the insurance companies and factories. In 1955, it joined the Young Men's Christian Association in the new Y building, on Broad Street and Park Place, to become the first YM-YWCA in the country. The older building was incorporated into the remodeled Newark Museum.

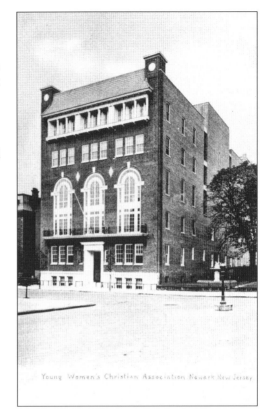

Young Women's Christian Association Newark New Jersey

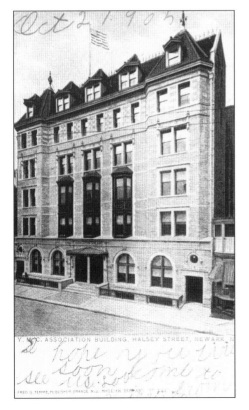

Y.M.C. ASSOCIATION BUILDING, HALSEY STREET, NEWARK, N.J.

This postcard of the old YMCA on Halsey Street in 1905 contains a message on the front telling the recipient, "We hope you will come to see us soon." The message is on the front because the earliest postcards lacked space for correspondence on the reverse side. After 1906, a line was drawn down the center of the back of the card and half of it could be used for messages.

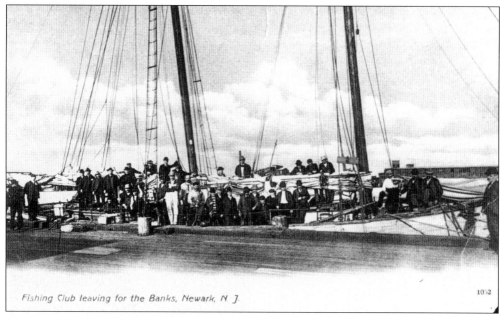

Fishing Club leaving for the Banks, Newark, N. J.

Members of a fishing club pose for a photograph before they sailed away from Newark for a day's fishing. Many clubs were formed during this period for various forms of recreation.

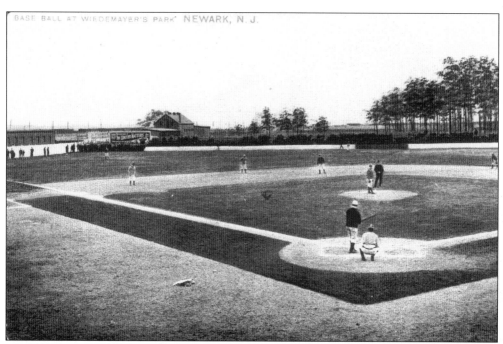

BASE BALL AT WIEDEMAYER'S PARK NEWARK, N. J.

The Wiedenmayer Brewery developed this baseball field in the Ironbound section of Newark for youths in the area. It provided the employees and their families a place to play baseball or watch the games. The teams met with others in Newark and the surrounding area.

The Polish National Home on Beacon Street was for Polish immigrants. Most of the homes today are clubhouses where Polish families celebrate their culture. Each ethnic group seemed to have a clubhouse of its own.

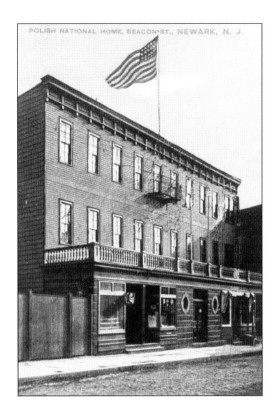

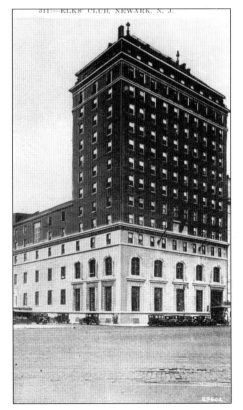

The Elks Club of Newark built this striking edifice on Broad Street opposite Lincoln Park in 1924. It later became the Essex House, a hotel. It was torn down when the Industrial Commerce Building next door was remodeled for senior citizen housing. The land serves as open space for tenants of that building.

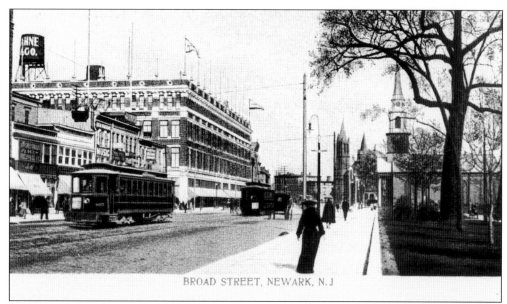

BROAD STREET, NEWARK, N.J

A woman in black strolls along the sidewalk by Military Park on Broad Street. Trolley cars travel along the almost empty street. A horse and wagon travels north. The 1901 Hahne Department Store is on the left, and the steeple of Trinity Episcopal church (Trinity St. Paul's Episcopal Church) is on the right.

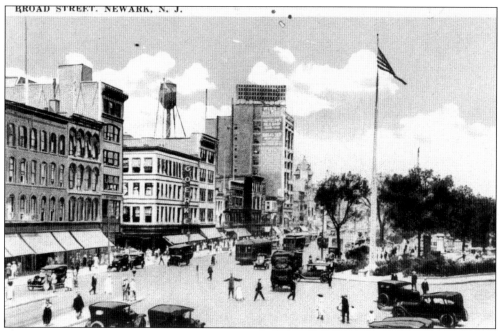

BROAD STREET, NEWARK, N. J.

Military Park begins where Broad Street meets Park Place. The flagpole is located at the original site of the hamlet's Liberty Pole, which stood before the American Revolution. Automobiles have replaced carriages and wagons. The number of pedestrians and trolley cars has increased as shoppers visit the stores. The Goerke Store, the white building in the center left, was built in 1912–1914. Nearly every store has an awning sheltering part of the sidewalk.

Nine

A VIEW FROM THE STREET

Newark was a pretty city during the golden age. Mansions and houses of worship lined High Street (now Rev. Dr. Martin Luther King Boulevard) and the three parks in the center of the city. New residential subdivisions such as Roseville, Forest Hill, Clinton Hill, Vailsburg, and Weequahic (after World War I) were being developed within the city limits. Each one attempted to be more beautiful than the others. Trees were planted along the streets. Residents took great pride in their flowers and fauna. Small neighborhood shopping areas, churches, schools, and professional offices were established to serve the people.

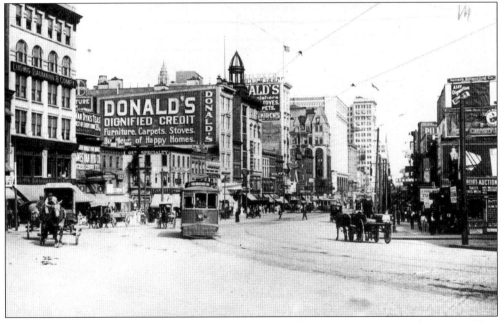

Wagons and streetcars travel along Market Street toward the Essex County Courthouse complex. Stores on the left include Ludwig Baumann & Company and Donald's Dignified Credit, offering furniture, carpets, and stoves. A sign assures the public that the company is a builder of happy homes, "our specialty." The South Orange Avenue trolley travels toward South Orange. The Newark Bill Posting Company sign is on the right, and below it is a sign advertising cigarettes.

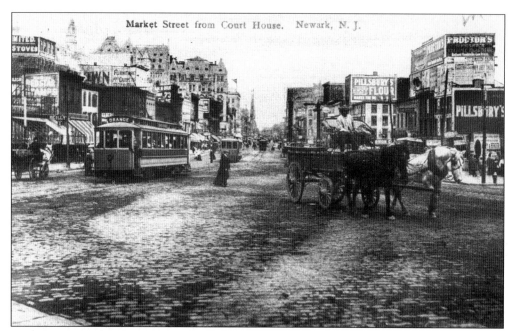

In this picture, also taken from the Essex County Courthouse, the cobblestoned streets are featured. They were necessary because of the numerous horses pulling wagons. A trolley traveling toward Orange is on the left. Two horses are pulling a delivery wagon on the right. A sign on the side of a building to the right rear advertises Proctor's Theater, charging low prices.

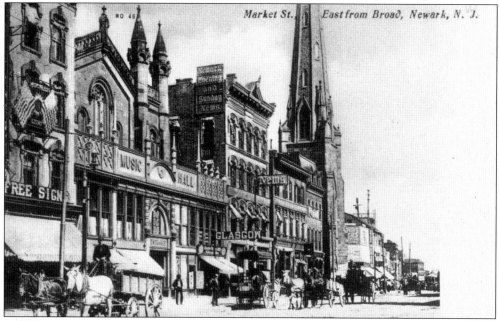

The Newark Evening News and the Newark Sunday News office was in the four-story building in the center. The newspaper was the leading daily in the state until it closed in the early 1970s. It began publication in 1883. Stephen Crane's father, Rev. Jonathan Townley Crane, preached in the Methodist church next to the News building. The Music Hall, at the left, was razed when the News enlarged its building.

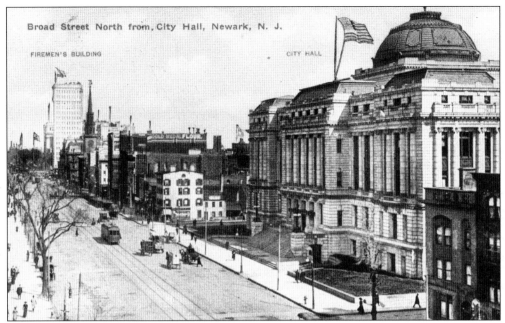

The Beaux Arts–style city hall on Broad Street was designed by architects John H. and Wilson Ely. It was built between 1903 and 1906 of granite and marble. Film crews frequently use the beautiful interior that features marble columns and a curved staircase for motion pictures.

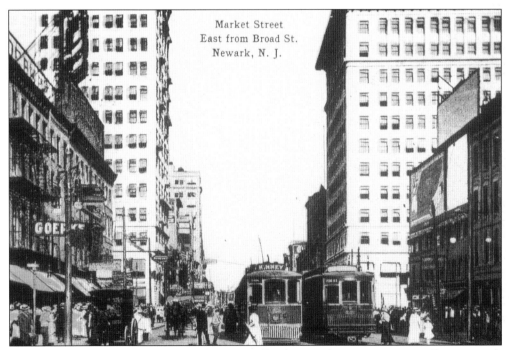

In this view looking east toward Broad Street, traffic clogs Market Street as two trolleys pass each other. The trolley on the left is labeled Kinney Trolley No. 729 and has a cowcatcher on the front. The trolley on the right is headed toward the Pennsylvania Railroad Station. The Kinney Building is the large white structure on the right.

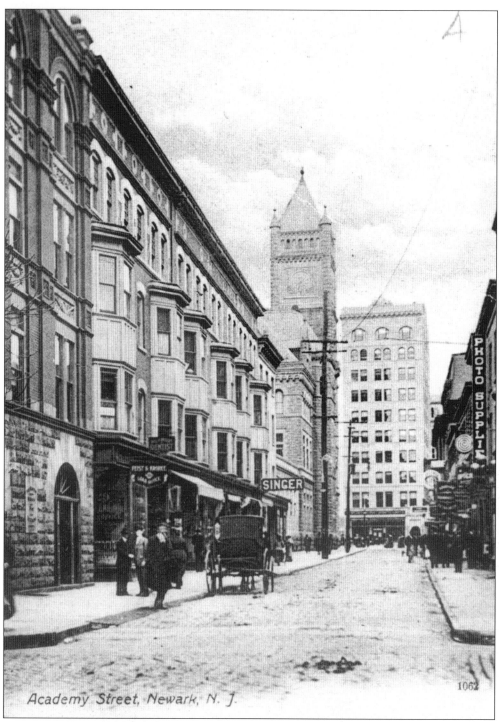

Academy Street, Newark, N. J.

Academy Street was the site of the Newark Academy after the Revolutionary War. Note how narrow the street is. In the 19th century, most streets were only wide enough for two wagons to pass each other. A Singer Sewing Machine Company store is midway down the block on the left. Photographic supplies are available in a store on the right.

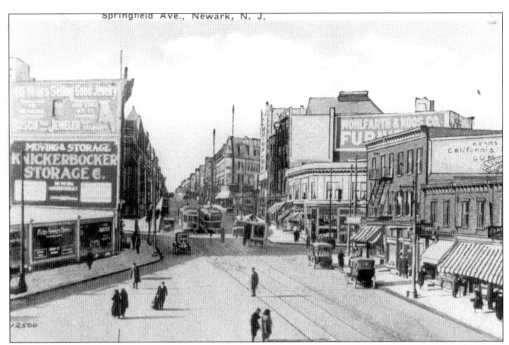

Springfield Avenue once was Springfield Turnpike. It connects Newark and Morris Avenue in Springfield Township. Businesses crowded along the Newark section. The signs on the left are for the Knickerbocker Storage Company and the Busch Company Jewelers, celebrating 10 years of selling good jewelry. The signs on the opposite side of the street are for Wohlfarth and Koos Company Furniture and Adams California Gum.

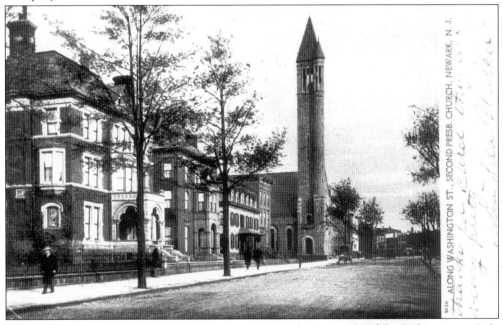

Washington Street was lined with beautiful mansions at the beginning of the 20th century. Only the Ballantine Mansion (left) remains. It has been purchased, restored, and furnished by the Newark Museum.

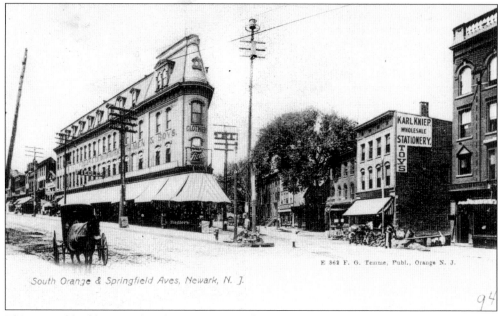

South Orange & Springfield Aves, Newark, N. J.

This unusual building stood at the intersection of South Orange and Springfield Avenues early in the 20th century. The builder used every bit of land he could to erect the apartment building. Because of the configuration of the streets, there are several plots like this one in the city. The Karl Kniep stationery and toy store is on the right. The site today is part of the Society Hill development.

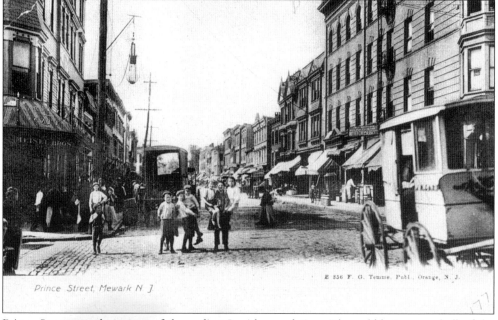

Prince Street, Newark N. J.

Prince Street was the center of the earliest Jewish population. The cobblestones and all of the stores, dwellings, and pushcarts are gone. The single synagogue on the street, Congregation Oheb Shalom, is being altered to house the Greater Newark Conservancy.

After 1900, multifamily dwellings replaced one-family and tenement houses on many streets in the city to serve the growing population. The Brodersen Apartment building, on High Street (now Rev. Dr. Martin Luther King Boulevard), was one of these. The builder also used every foot of a triangular lot for this apartment.

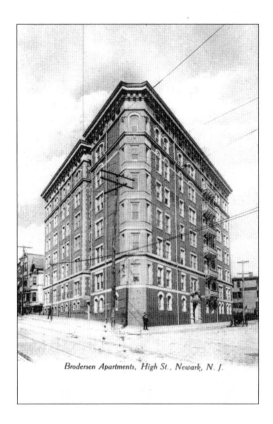

Brodersen Apartments, High St., Newark, N. J.

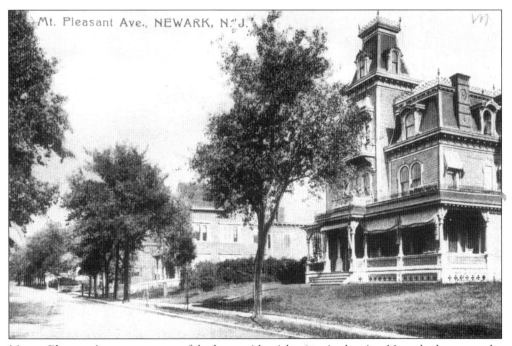

Mt. Pleasant Ave., NEWARK, N. J.

Mount Pleasant Avenue was one of the best residential streets in the city. Note the house on the right with its tower, mansard roof, wraparound porch, and lawn. The street was lined with trees.

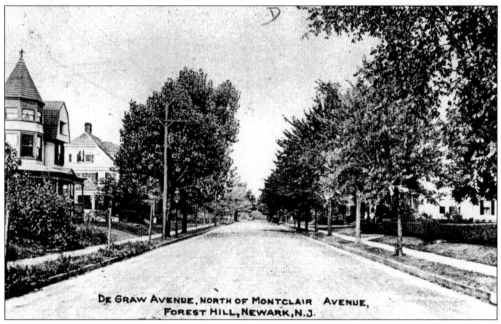

De Graw Avenue, in the Forest Hill section, was a tree-lined street with large single-family homes. The area was part of Woodside Township briefly, and then Woodside rejoined Newark.

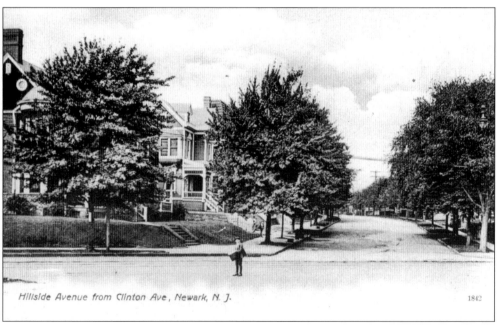

Hillside Avenue, in the Clinton Hill section, continued to be an upscale residential community through the golden age of Newark. Many professionals lived in the area, and some of them used their homes as offices for their medical, dental, or law practices.

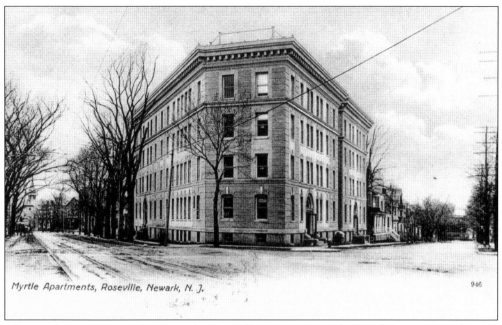

Myrtle Apartments, Roseville, Newark, N. J. 946

The Myrtle Avenue Apartments, in the Roseville section, were close to the East Orange border. Here, too, multifamily buildings replaced single-family houses.

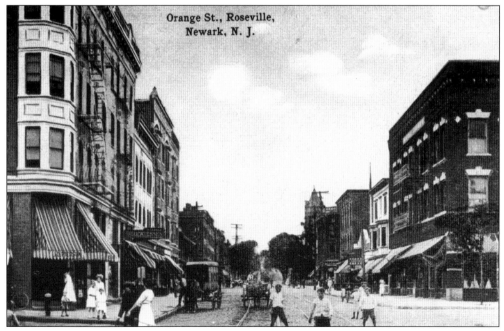

Orange St., Roseville, Newark, N. J.

The Roseville section was the first large residential area built outside the city center. Orange Street had little traffic at the beginning of the 20th century. These boys were able to play in the street without fear of being struck by vehicles. Some of them probably lived in the new apartments above the stores.

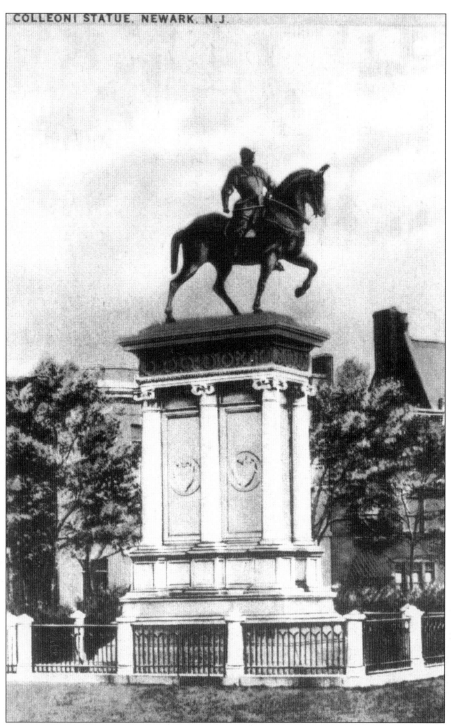

COLLEONI STATUE, NEWARK, N.J.

In Clinton Park, the Colleoni statue, by Andrea de Verrocchio, is a copy of one in Venice, Italy. The bronze equestrian figure was sculptured by J. Massey Rhind, who also did the statue of George Washington and his horse in Washington Park. The Colleoni stands on a pedestal designed by Rhind. Given to the city by Christian Feigenspan, it was unveiled in 1916.

THE CITY
BEAUTIFUL MOVEMENT

During Newark's golden age, the Frederick Law Olmsted firm arrived in the city to design seven parks and industrialists presented Newark with several beautiful statues for the parks.

The parks included Bound Brook Park, with 359.72 acres in 1895, the first county park in the nation; Weequahic Park on Bound Creek, the traditional border between Newark and Elizabethtown, with 311.33 acres; West Side Park, with 31.36 acres, the ninth largest park in Essex County; Vailsburg Park, with 30.12 acres, the 10th largest; and Ivy Hill Park, with 18.96 acres and the highest elevation. The remaining county parks, both in the Ironbound section, are East Side Park (now Independence Park), with 12.69 acres, and Riverbank Park, with 10.77 acres, the smallest county park in Newark.

The site for Branch Brook Park once contained Blue Jay Swamp, a private reservoir to supply water to dwellings in the Forest Hill section, and a portion of the Morris Canal. Today, the park has a skating rink, the Ballantine Gates, and in April, the cherry blossom festival. Weequahic featured trotting races, an 85-acre lake, a water bird house, bridle paths, and rowing. West Side and Independence Parks provided athletic activities for West Side High School and East Side High School, respectively. Today, Ivy Hill's tennis courts are used by students at Seton Hall University in South Orange.

All the parks contained flower gardens, large lawn areas, shade and flowering trees, winding roads and paths, and a variety of bridges. Today's parks, although altered from the early-20th-century design to meet current needs, continue to serve the people of Newark with playing fields and passive areas.

In addition to the county parks, Newark has three large city parks along Broad Street—Washington, Military, and Lincoln Parks—as well as several vest-pocket parks. These contain statues by J. Massey Rhind, Gutzon Borglum, Henry Kirke Brown, Giuseppe Ciochetti, Karl Gerhardt, Chauncey B. Ives, Allen G. Newman, Charles Henry Niehaus, and William Clark Noble. Most of the statues were unveiled during Newark's golden years.

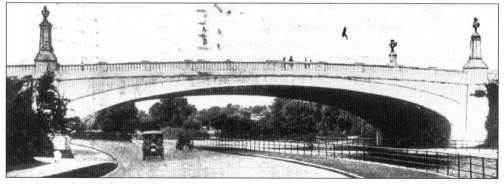

Branch Brook Park has three vehicular bridges crossing it. This one is over the Park Boulevard and under Park Avenue. The park has three bridges and few intersections, despite the fact that it is located in a busy section of North Newark. It is the first county park in the United States. The Essex County Park Commission was formed in 1895.

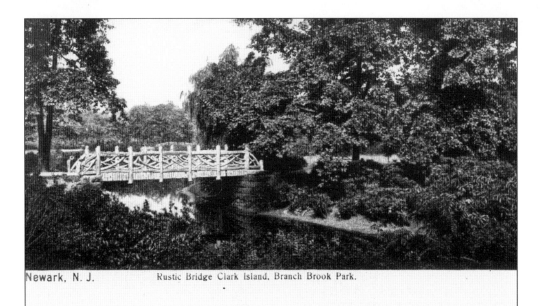

Newark, N. J. Rustic Bridge Clark Island, Branch Brook Park.

A rustic bridge crosses a stream to Clark Island in Branch Brook Park. The island is named for the George A. Clark family. George Clark founded the Clark Thread Company in Newark and started a reservoir in the Branch Brook Park area to supply water to the residents of the Forest Hill section before the site became a county park. The reservoir was incorporated into the park design by landscape architect Franklin Law Olmsted, who designed the park.

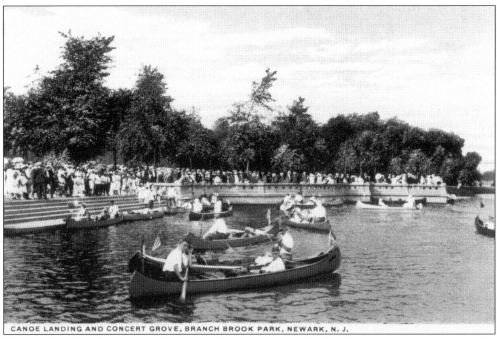

CANOE LANDING AND CONCERT GROVE, BRANCH BROOK PARK, NEWARK, N. J.

A sunny Sunday afternoon in the summertime attracts hundreds of people to a concert grove in Branch Brook Park, as other people paddle in their canoes nearby. The Essex County Park Commission was organized in 1895, and Branch Brook Park was begun in 1896. It covers 359.72 acres, the largest developed park in Essex County.

112

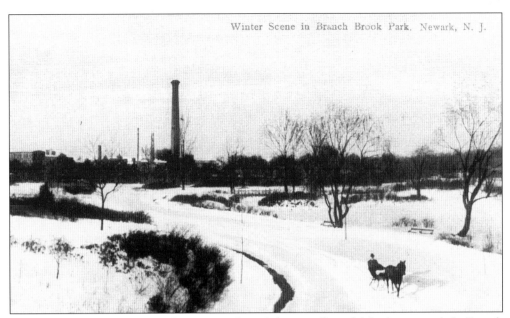

The fun continues even in inclement weather. A horse pulls a sleigh along a path in Branch Brook Park in the snow. The storm apparently kept everyone else out of the park. Note how the park road curves. This is the romantic style favored by the Victorians in the golden age.

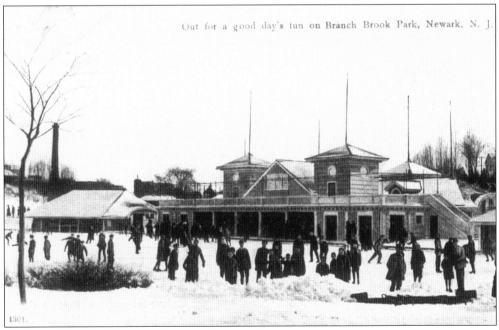

Out for a good day's fun on Branch Brook Park, Newark, N. J.

A snowfall brought people to Branch Brook Park for a day of fun in the snow. Ice-skating was a popular sport for many. Unfortunately, at the beginning of the 20th century, people had very little time for fun. Many of them worked six 12-hour shifts and part-time on Sundays.

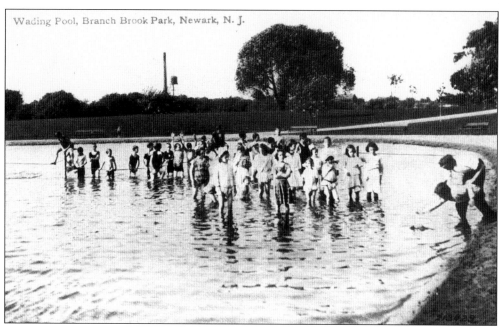

Wading Pool, Branch Brook Park, Newark, N. J.

Children enjoy wading in Branch Brook Park. The park is located at a site known as Blue Bird Swamp, a former reservoir created by George A. Clark and his neighbors. Note that only a few of the children appear to be wearing swimsuits.

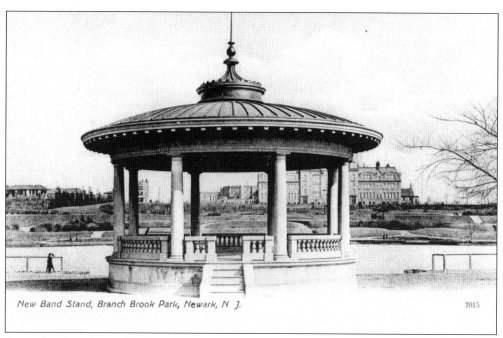

New Band Stand, Branch Brook Park, Newark, N. J. 2015

A new bandstand was placed in Branch Brook Park for free band concerts on Sunday afternoons and summer holidays. There were many bands in Newark during the golden age.

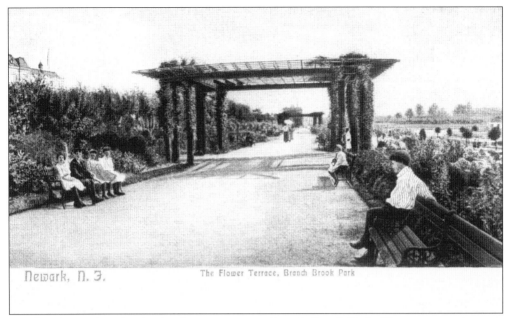

Newark, N. J. The Flower Terrace, Branch Brook Park

People relax on benches in the flower terrace at Branch Brook Park. The county parks were noted for their attractive flower displays.

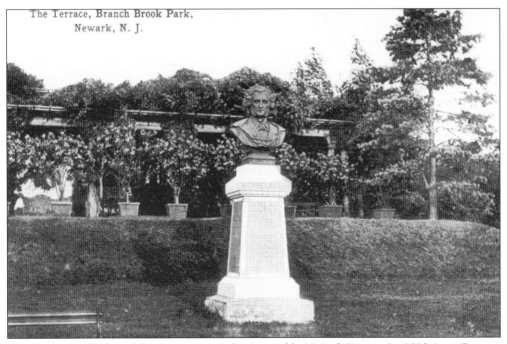

The Terrace, Branch Brook Park,
Newark, N. J.

The bust of Felix Mendelssohn was won by Newark's United Singers in 1903 in a German celebration. It was placed on a pedestal in Branch Brook Park. It remained there until the 1970s, when it was stolen from a park greenhouse, where it had been taken for a cleaning and safekeeping. It was recovered and now is in the Essex County Park Commission Administration Building.

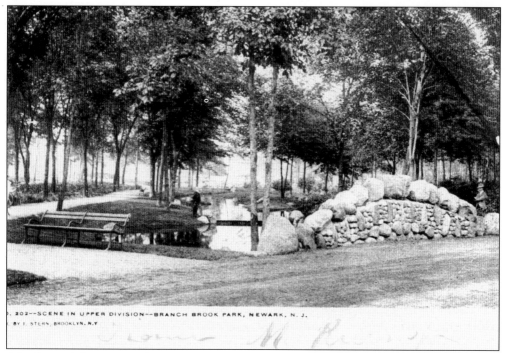

A bridge with huge stones helps to carry people and vehicles across one of the many streams in Branch Brook Park. The bridge is located in the upper division of the park.

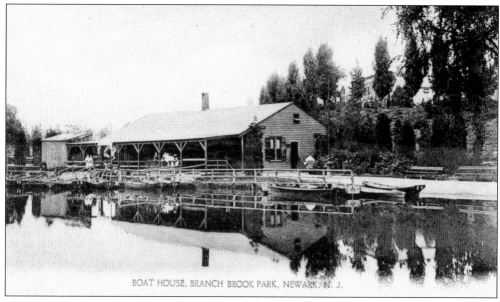

BOAT HOUSE, BRANCH BROOK PARK, NEWARK, N. J.

Visitors to Branch Brook Park were able to rent boats for a ride through the park. The park was four miles long and a quarter of a mile wide. The park was named for one of the brooks that flowed through it. Second River and several other brooks are also located in the park.

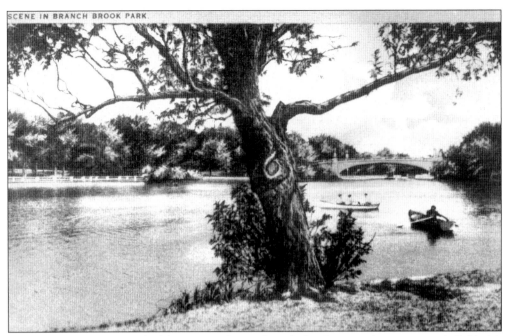

An old tree on the bank of a lake in Branch Brook Park dominates a picture postcard. Behind it are a vehicular bridge and rowboats on the lake.

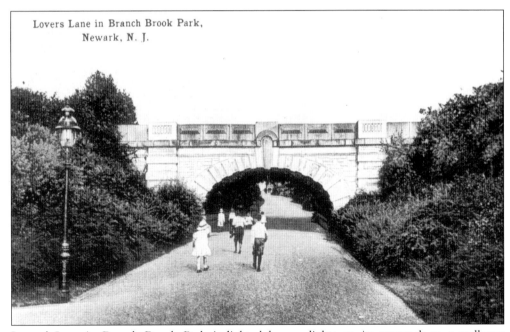

Lovers' Lane in Branch Brook Park is lighted by gas lights on its approach to a walkway underpass. The walkway is bordered by flowering shrubs.

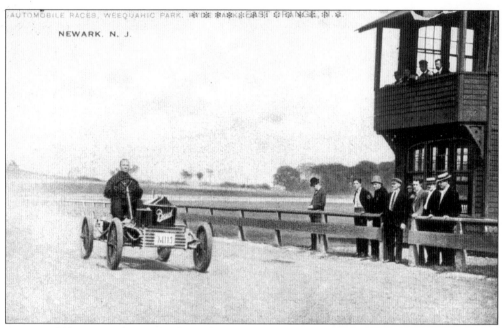

AUTOMOBILE RACES, WEEQUAHIC PARK. IN DE PARK EAST ORANGE, N. J.

NEWARK, N. J.

A stripped-down Buick travels along the racetrack at Weequahic Park, and a group of men observe it *c.* 1908.

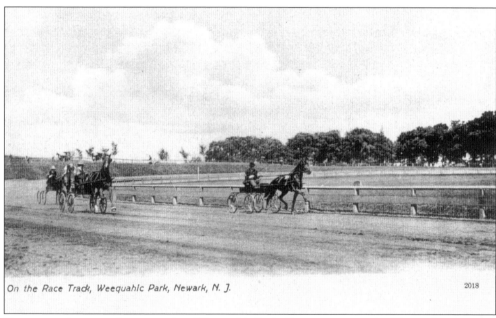

On the Race Track, Weequahic Park, Newark, N. J. 2018

Trotters work out on the racetrack at Weequahic Park. For many years, the Weequahic Amateur Trotting Club operated the races that moved to Robert L. Johnson Park in Highland Park in 1965. From 1867 to 1900, prior to the development of the park, the Waverly Fair, a state fair, was conducted in the area by the New Jersey State Agricultural Society. The fair moved to Trenton and became the state fair.

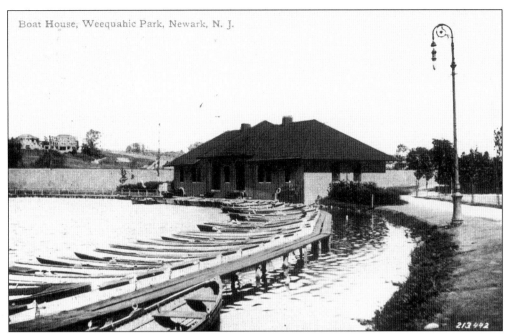

Rowboats, waiting for customers, are docked at the boathouse near the Meeker Avenue entrance to Weequahic Park. Canoes or rowboats were available for rental from *c.* 1901 to the 1960s. The 85-acre lake, entirely within the city limits, is the largest lake in Essex County. There also is an 18-hole golf course, one of three in the county park system.

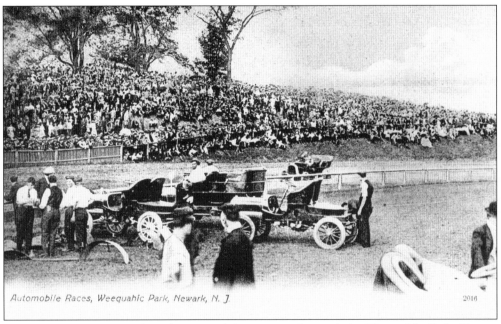

Crowds gathered to watch early automobile races at the track in Weequahic Park. Barney Oldfield and Frank Kramer were two of the outstanding racers. The races were sponsored by the New Jersey Automobile and Motor Club.

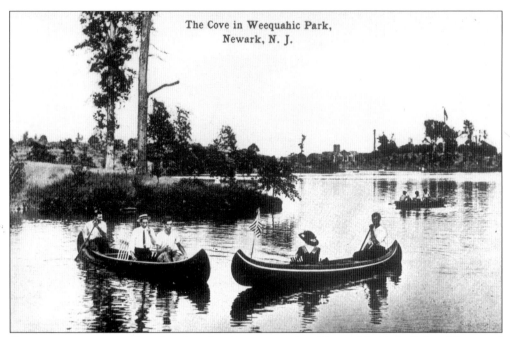

The Cove in Weequahic Park,
Newark, N. J.

Canoes were rented when boating first began on the Weequahic Park Lake. The word Weequahic is said to mean "head of the cove." The cove would be the area near Meeker Avenue. The name was given to the park and the residential district adjacent to it.

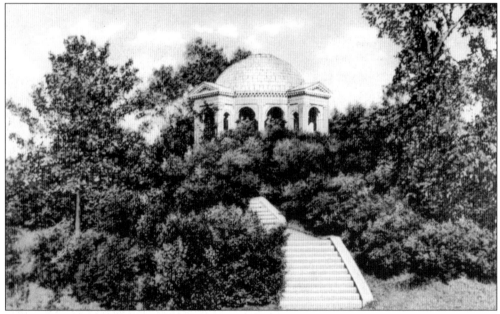

The Greco-Roman pavilion was dedicated in 1916 during the 250th anniversary of the settlement of Newark. It is located on Divident Hill, so named by the settlers of Newark and Elizabethtown because the boundary between the two communities was established with God's love. The hill, now located in Weequahic Park, is 80 feet above sea level and the first highest point from Newark Bay. It is on the old Upper Road (Elizabeth Avenue) and opposite the road to Lyon's Farms (Lyons Avenue).

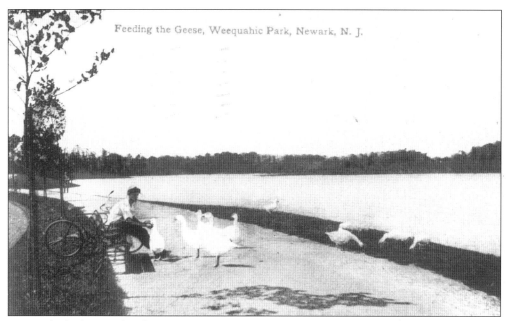

Feeding the Geese, Weequahic Park, Newark, N. J.

A man feeds the gaggle of geese at the Weequahic Park lake. At one time, the lake featured a fenced facility for water birds.

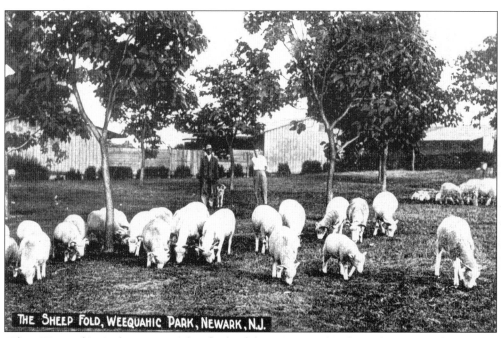

THE SHEEP FOLD, WEEQUAHIC PARK, NEWARK, N.J.

When Weequahic Park was opened, a flock of sheep was used to keep the grass in the 311.33-acre park trimmed. A man with a dog herded the sheep. The adjacent Evergreen Cemetery, located in Elizabeth, Union (later Hillside), and Newark also used sheep to keep the grass short.

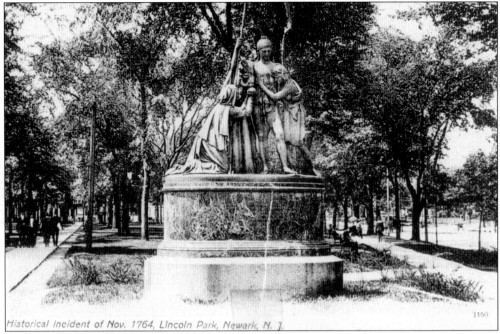

Historical Incident of Nov. 1764, Lincoln Park, Newark, N. J.

The statue of an American Indian group depicts an incident in 1764. The kneeling figure is the mother of the young woman at the right. The mother is pleading for her daughter's release by the man standing. The younger woman was captured by Indians as a child and is the wife of the Indian man, whom she does not want to leave. Chauncey B. Ives was the sculptor. The monument is in Lincoln Park.

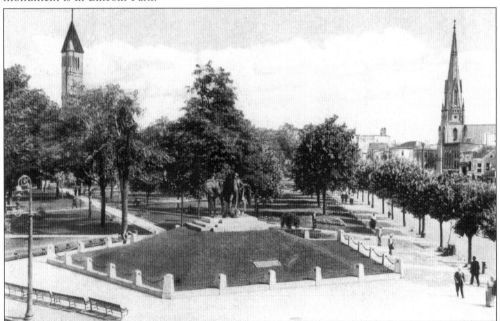

This is a view of Washington Park showing the mound with the J. Massey Rhind statue of Gen. George Washington. On the left above the trees is the spire of the Second Presbyterian Church. On the right is the North Reformed Church.

122

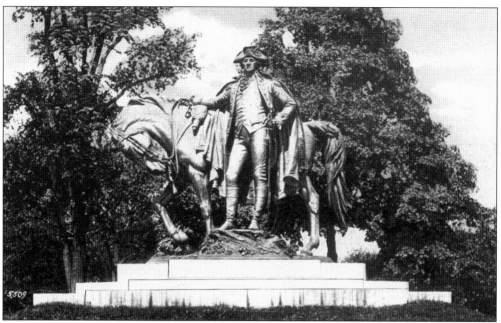

The statue of Gen. George Washington, by J. Massey Rhind, shows Washington standing beside his horse looking down on Broad Street, the route he took on his famous retreat in November 1776. The statue was unveiled in 1912. It is in Washington Park.

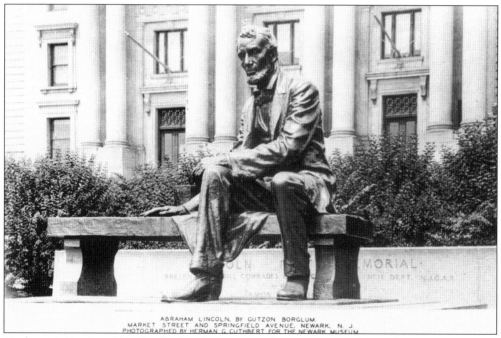

The seated Abraham Lincoln also is a famous statue by Gutzon Borglum. This one is in front of the Essex County Courthouse. It was unveiled in 1911, with Theodore Roosevelt as a guest. Children frequently sit on Lincoln's knee.

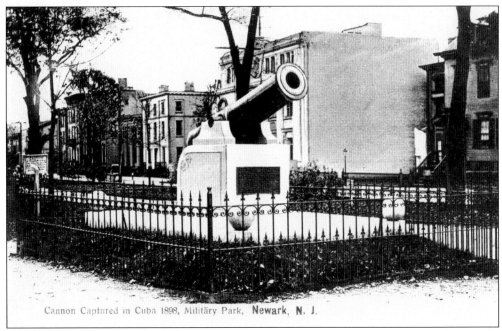

Cannon Captured in Cuba 1898, Militäry Park, **Newark, N. J.**

A cannon captured during the Spanish-American War in Cuba in 1898 is on display in Military Park.

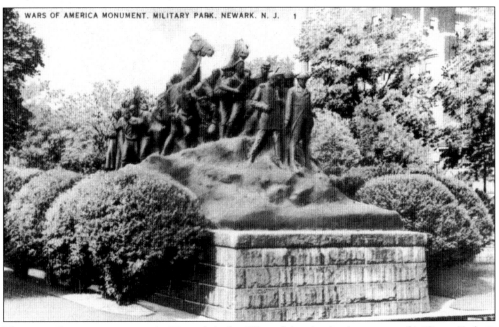

WARS OF AMERICA MONUMENT. MILITARY PARK. NEWARK. N. J. 1

The most famous monument in Newark is the *Wars of America,* in the center of Military Park. It is by Gutzon Borglum, and it was unveiled in 1926. The figures are from the Revolutionary War, the Civil War, the Spanish-American War, and World War I. Figures also include a Red Cross nurse and the aviator John Purroy Michell. Amos Van Horn donated the monument to Newark.

Philip Kearny, a career army officer killed in the Civil War, spent much of his childhood at the Kearny Cottage, his grandparents' home on the future site of the Newark State Teachers College. Kearny lost an arm in the Mexican War but served as a major general with the 3rd Corps of the Army of the Potomac in the Civil War. He was killed at Chantilly, Virginia. The statue by Henry Kirke Brown was dedicated in Military Park in 1880. Kearny Township wanted to have the statue, but Newark objected and kept it. The township has since obtained another statue. Newark State Teachers College moved to Green Lane Farm in Union Township, the former home of Hamilton Fish Kean, in 1958. It is now Kean University.

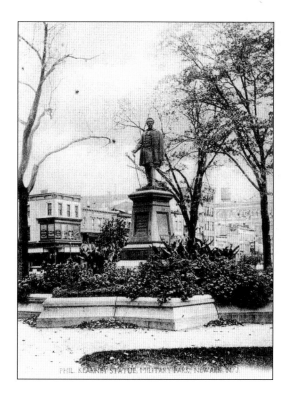

PHIL. KEARNY STATUE, MILITARY PARK, NEWARK, N.J.

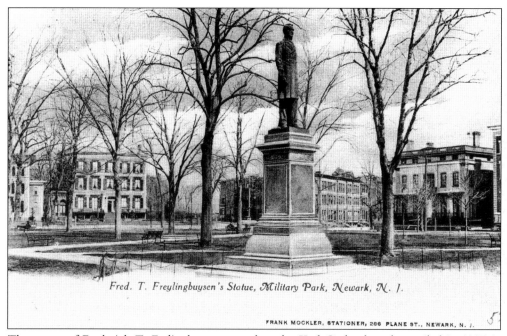

Fred. T. Freylingbuysen's Statue, Military Park, Newark, N. J.

FRANK MOCKLER, STATIONER, 266 PLANE ST., NEWARK, N. J.

The statue of Frederick T. Frelinghuysen was done by Karl Gerhardt and unveiled in 1905 in Military Park. It was moved to another site in the park in 1961. Frederick Frelinghuysen had a life of public service. He was an attorney general for New Jersey, a delegate to the Peace Congress on the eve of the Civil War, a U.S. senator from 1866 to 1877, and secretary of state.

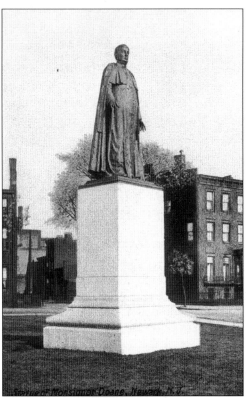

The statue of Msgr. George Hobart Doane, by William Clark Noble, was dedicated in 1908 in Rector Park (later Doane Park), on Broad Street and Park Place (later Center Street). A convert to Roman Catholicism, he was pastor of St. Patrick's Pro-Cathedral and took an active part in the city's activities.

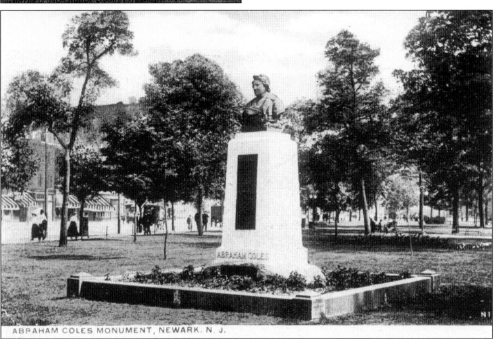

The bronze bust of Dr. Abraham Coles stands in Washington Park, where it was unveiled in 1897. It is by sculptor John Quincy Adams Ward. Abraham Coles gave up the study of law to become a medical doctor. He was president of the New Jersey Medical Society.

126

On the Swings, East Side Park, NEWARK, N. J.

A teacher in the center of the postcard monitors a class on a visit to East Side Park (now Independence Park). Note some of the children are seated on the swings, while the others stand in a straight line for the photographer. The park area on Walnut, Oliver, Adams, and Van Buren Streets was purchased in 1895 for a neighborhood park and designed by the Olmsted brothers. Bocce courts are among the park's facilities.

Boys demonstrate their abilities on apparatus in the boys' playground at East Side Park. Note the knickers most of the boys are wearing. Trousers were for older boys.

The Hiker, by Allen G. Newman, was placed in the center of McKinley Circle, at the intersection of Belmont Avenue (now Irving Turner Boulevard) and Clinton Avenue opposite the Central Presbyterian Church. The statue was introduced at the Jamestown Exposition in 1907 and became very popular throughout the nation. The one in Newark was donated to the city by the United Spanish War Veterans and unveiled on Memorial Day 1914. In the 1980s, the statue was stolen.